D0905124

MURDER
AND MYSTERY IN
ATLANTA

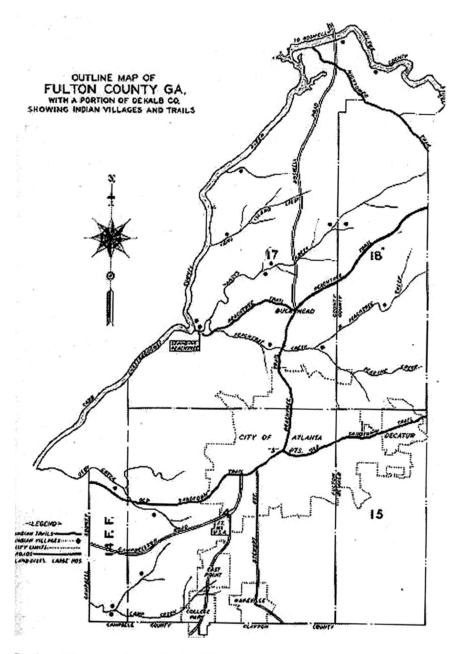

Roads and Native American trails, circa 1815, with late nineteenth-century Fulton County and city of Atlanta outlines overlaid.

MURDER
AND MYSTERY IN
ATLANTA

CORINNA UNDERWOOD

THE
History
PRESS

Published by The History Press
Charleston, SC 29403
www.historypress.net

Copyright © 2009 by Corinna Underwood
All rights reserved

First published 2009

Manufactured in the United States

ISBN 978.1.59629.766.1

Library of Congress CIP data applied for.

Notice: The information in this book is true and complete to the best of our knowledge. It is offered without guarantee on the part of the author or The History Press. The author and The History Press disclaim all liability in connection with the use of this book.

All rights reserved. No part of this book may be reproduced or transmitted in any form whatsoever without prior written permission from the publisher except in the case of brief quotations embodied in critical articles and reviews.

Dedicated to June Pearl Carson
and the memory of
Reginald Carson

CONTENTS

ACKNOWLEDGEMENTS

Special thanks go to Rachel Johnston for sharing her family knowledge of Martin and Susan DeFoor and Lance Haugan for his photographic expertise. Thanks also to Glen Martin, Robert Davis, Ken Denney, Professor Anne J. Bailey and Sue VerHoef for help with research.

INTRODUCTION

Atlanta is a dynamic city that has seen many changes over the past decades. Census reports indicate that the population stood at 4,917,717 in the twenty-eight-county Atlanta Metropolitan Statistical Area in 2006. According to statistics compiled by the U.S. Department of Justice, between 1976 and 2005, 53.7 percent of homicides occurred in large cities with a population of 100,000 or more. The FBI reports that the number of murders in Atlanta jumped by 22 percent in 2006, far surpassing the national murder increase of 1.8 percent.

Each chapter of this book covers specific cases of homicide, or suspected homicide, that took place in Atlanta dating from the 1840s to the 1990s. Interestingly, regardless of the era, many of the motives remain the same: hatred, prejudice and money. Early cases, such as the Atlanta Ripper murders and the murder of Mary Phagan, highlight racial tensions that were prominent in the South from the beginning of the twentieth century. Cases such as the Atlanta youth murders reveal how new developments in forensic technology, such as fiber analysis and DNA testing, have helped to provide evidence that was previously unavailable or inconclusive. While cases such as the Atlanta transgender murders indicate a need for stronger laws and more exhaustive police work, other cases, such as the disappearance of Mary Shotwell Little, remain unsolved in spite of the most thorough investigations.

There remain thousands of unsolved cases in and around the metropolitan area. Cold case squads are committed to reopening old murder cases, some going back thirty or forty years, to contact precious witnesses, locate new ones and recover new evidence. Their aim is to capture offenders who are still at large and bring peace and closure to victims' families.

Atlanta's First Homicides

The area of Georgia now familiar as the metropolitan city of Atlanta was once a Native American village called Standing Peachtree, inhabited by the Creek and the Cherokee. Back in 1825, the Creek nation ceded its land to the State of Georgia. The Cherokee continued to live side by side with their white neighbors until 1835, when, under the Treaty of New Echota, the Cherokee agreed to move west and Georgia took control of former Cherokee lands. This act ultimately resulted in the tragic Trail of Tears.

The Georgia General Assembly voted in favor of building the Western and Atlantic Railroad in 1836. A year later, work started on the eastern terminus, and the new settlement developed there was itself named Terminus. Within the next five years, the settlement had grown to thirty residents and six buildings, and the town was renamed Marthasville for ex-governor Wilson Lumpkin's daughter Martha. Georgia Railroad chief engineer J. Edgar Thompson suggested the name Marthasville be replaced by Atlantica-Pacifica in 1845, and the name was shortened to Atlanta and made official the same year.

Georgia Lynch Law

Lynch law was a form of extrajudicial punishment meted out by vigilante mobs for presumed crimes. Lynching was popular throughout Georgia before and after the Civil War. Prior to the

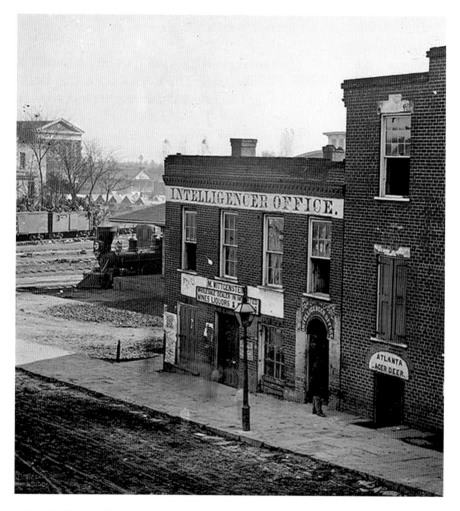

Atlanta Intelligencer office and railroad depot, 1864.

war, lynch mobs usually targeted anyone opposing slavery. After the war, white Georgians used lynching as a means of terrorizing free African American people who were voting. From 1868 to 1871, the Ku Klux Klan was responsible for more than four hundred lynchings involving African American men and women for supposed crimes against white people. Victims were often burned, hanged or sometimes beaten to death. The list of supposed crimes deserving of lynching ranged from raping a white woman to arguing with a white man.

In 1881, the *Atlanta Constitution* expressed the shame and contempt that many of its readers felt about lynchings by expounding on the inadequacy of the legal system and demanding that lawmakers instigate a long-awaited change. In response, Georgia legislators attempted to suppress lynch law in 1897. Although the majority of representatives were against lynch law, few of them had a constructive strategy for stopping it. The *New York Times* reported that J.L. Boynton of Calhoun highlighted the complexity of the issue:

> *Lynching, in my opinion, is the result of combined causes. The practice has more or less prevailed in times of popular excitement, and especially in the new settled reasons before the establishment of the power of civil government. Criminal laws are imperfect, at best, and they are not administered with that vigor necessary to inspire confidence in their sufficiently. In criminal trials "justice" is often sidetracked and technicalities given the right of way. The people who do not understand such practice observe this, and losing faith in the adequacy of the law, take the law into their own hands.*

Representative W.S. West of Lowndes firmly expressed his doubt in any resolution:

> *I do not think that the General Assembly can enact any law that would have any effect upon lynching. Sometimes there are crimes in the state that call for lynching, while at other times there is no excuse for it in the least. It is a difficult question to determine. I can only say stop the crime and you will stop the lynching.*

J.W. Law, the only African American representative in the House, suggested a plan to control lynching: "The only solution of the lynching question in Georgia that I can see is the education of the negro. Ignorance causes more crime in Georgia than any other thing. Educate the negro and you will prevent the crime of rape."

In 1893, the legislature passed a law that required law officials to summon a posse to quell mob violence. This meant that any sheriff failing to follow the new instruction could be charged with a misdemeanor and any citizens participating in the mob could be charged with felony or possibly murder. Some legislators, however, saw the shortcomings in the statute, the main one being that local

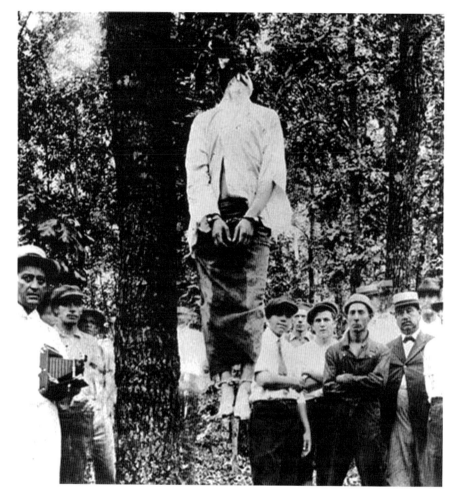

The lynching of Leo Frank.

law enforcers were unlikely to go to the extent of prosecuting mob participants.

Lynchings continued to decline in the beginning of the twentieth century, and though the last "confirmed" lynching took place in Marion, Indiana, in 1930, with the hanging of Thomas Shipp and Abram Smith, Shipp and Smith were certainly not the last victims of this type of mob reaction.

FIRST ATLANTA HOMICIDES

The very first recorded homicide to take place in Atlanta occurred in 1848. Though few details of the incident were recorded, according to historical archives the victim was a man named McWilliams. He was stabbed to death by Bill Terrell, who escaped and was never caught.

Local law enforcement was a little more successful in 1851, when Elijah Bird stabbed Nat Hilburn to death. Bird's father had owed Hilburn money for some time. Impatient for his payback, Hilburn got into a fight with Bird over the matter. The argument became increasingly heated, and Bird stabbed Hilburn in the neck, killing him within minutes. Bird was tried by the Supreme Court, and eventually, in 1853, he was granted a pardon on the condition that he left the state. Bird moved to Louisiana, married and ran a plantation for several years until he met his own untimely end. During a time of minor trouble with the plantation workers, one of Bird's men followed him out to the field one evening and hit him over the head with a cane hoe, splitting his skull and killing him instantly. Bird's killer was never captured.

A HEINOUS CRIME IN FULTON COUNTY

In 1855, a murder occurred in Fulton County that reportedly became renowned as one of the most remarkable crimes in the short history of the area. Samuel Landrum was a farmer from Carroll County who had journeyed from his home to Atlanta to sell his cotton. He had a successful day at the market and sold all he had brought with him for the sum of $600. Satisfied with his day's work, he began his journey back to the farm. What Landrum did not know was that he had been watched all day by a cunning trio of young men. Assuming that he had the money he had made on his person, the three began to stalk the farmer's journey home. Landrum was traveling steadily down the McDonough road in his buggy, not quite a mile from town, when he was suddenly overtaken by Gabriel Jones, Radford J. Crockett and John Cobb Jr.

According to Crockett's later confession, two of the young men climbed up into the buggy and rode along with Landrum for a while

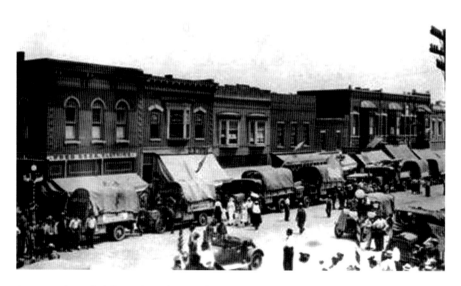

A convoy through Atlanta, late nineteenth century.

before striking him unconscious. The youths dragged the old farmer from the buggy and to the side of the road. They then beat his head to a pulp and robbed him of everything he had on his person. They were, however, disappointed; instead of the $600.00 they had hoped to find, they garnered only $1.50.

After the murder, the three split up, and some time passed before police located Radford Crockett in Alabama, where he made a full confession. Crockett was jailed and assigned the Honorable Charles Murphy as his counsel. When the charges against him were read in court, Crockett astounded the courtroom by admitting his guilt, despite the recommendations of his counsel. Crockett explained that he felt the weight of his crime upon him and did not want to add to it with the sin of lying. The young man believed that the only way he could be pardoned for his terrible deed was to be hanged. His wish was granted and the sentence was carried out in June 1858.

Cobb and Jones were apprehended shortly after. Cobb was tried, convicted and swung from the gallows in 1859. This was to be the last hanging in Atlanta before the war. Jones's fate was less unfortunate. He pleaded guilty at his trial in 1859, knowing that he was to be sentenced to the penitentiary at Milledgeville for the rest of his life. He had not been incarcerated long when Sherman began his destructive march

to the sea. Before his army reached Milledgeville, the convicts were released and they enlisted for service. It is recorded that Jones fought with the Northern soldiers and then managed to escape. He was not heard of again.

THE MURDER OF CALVIN WEBB

On December 31, 1858, bailiff Calvin Web arrested William A. Choice on a bail warrant for outstanding debts amounting to ten dollars. At the time, imprisonment for debt was part of Georgia law, but Choice secured bail, and that should have been the end of the matter. However, Choice happened upon Web the following morning, pulled his pistol and fired two shots at the bailiff. The second shot hit Web in the chest and ended the man's life. The murder caused a great deal of public outrage, and Choice barely escaped lynching by the mob.

Choice was tried before a magistrate's court on January 2, 1859. He made a desperate plea that he had committed the crime because he was suffering from insanity brought on by a head injury some nine years earlier. The attempt to secure sympathy failed, and he was sentenced to be hanged. The defender Honorable B.H. Hill, remained convinced of his client's insanity and used his influence to obtain him a pardon. Choice was then committed to an asylum for a short period before being liberated. During the Civil War, he fought with the Confederate army. He died a few years after the war had ended at his home in Rome, Georgia.

THE EXECUTION OF SLAVE TRADER
NATHANIEL GORDON

In 1862, President Abraham Lincoln made a dramatic move against slavery by approving of the execution of illegal slave trader Nathaniel Gordon. Though Gordon, originally from Portland, Maine, had been trafficking slaves illegally for more than forty years, no one had previously bothered to enforce the law. Gordon's ship *Erie* was captured by the USS *Mohican* fifty miles from the port at Sharks Point, West Africa. At the time, he was carrying 897 men, women and child

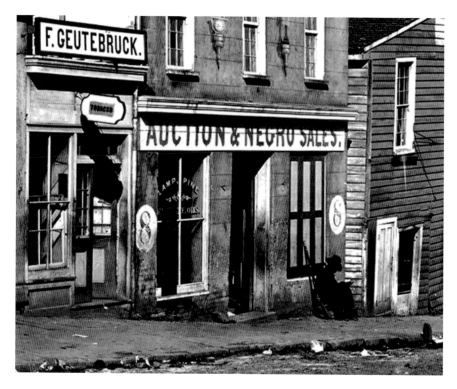

Atlanta slave market, 1864.

slaves aboard his ship, ranging from age six months to forty years. The conditions on the ship were cramped and insanitary, and many of the passengers were suffering from disease and malnutrition. During the fifteen-day passage, 21 of the captives died; their bodies were tossed overboard.

Once the ship was detained, the slaves were taken to Liberia, and Gordon was sent to New York for trial with his shipmates David Hale and William Warren. Before Judge William Shipman, Gordon's defense claimed that the trader had sold the ship to a Spaniard before the slaves were boarded, and that in fact he was merely a passenger. But the story fell apart when a number of seamen attested that Gordon had offered them a dollar per head for every slave who made it safely to their destination in Cuba. After an original mistrial, Gordon was convicted on November 9, 1861. President Lincoln issued a stay of execution and a new date was set for February 21, 1862.

On the night before his execution, Gordon made a suicide attempt by drinking strychnine. Dr. Simmons, the prison physician, saved him from near death, and Gordon was hanged from the gallows on February 21, 1862. Nathaniel Gordon was the only American slave trader ever to be tried, convicted and executed under the Piracy Law of 1820.

MURDER IN THE CAPITOL

The murder of Colonel Robert A. Alston generated pubic outrage in 1879 when the victim was hunted and shot down in the state capitol among a number of prominent witnesses who made little attempt to prevent the crime. Alston was a politician and lawyer who had moved from Macon to Atlanta during the Civil War. He was elected to the general assembly in 1879, and from then on he devoted himself to improving the abhorrent conditions in Georgia prisons. His focus was the convict lease system, which had been in place since 1868. After the passing of the Thirteenth Amendment, slavery as a means of labor became illegal and Georgia landowners were struggling to find a manageable labor force. The convict lease system permitted Georgia landowners to hire convicts from the State Penitentiary in Milledgeville to work on the land. Georgia lawmakers were also in favor of the idea, as it helped to offset the mounting costs of running the prison. Because convict leasing became such a major source of revenue throughout the state, attempts at reform were largely unsuccessful.

It was Colonel Robert A. Alston's battle against the convict leasing system that brought about his untimely demise. The conflict began in 1879, when Senator John B. Gordon gave Alston power of attorney to sell his interest in Penitentiary Company Number Two. The sale adversely affected landowner Edward Cox, who had been subleasing sixty convicts from the company to work on his farm. Outraged by Alston's choice of buyer, Cox tracked him down to a barbershop on March 11, 1879, and demanded that he cancel the sale. On being told that his demands could not be met, Cox flew into a rage and threatened Alston, telling him that he should arm himself.

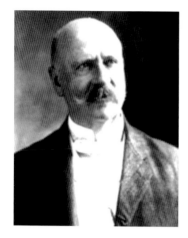

Left: Augustus O. Bacon, Speaker of the House of Representatives.

Below: Marietta Street, Atlanta, 1864.

Later that afternoon, State Treasurer John W. Renfroe returned to his office after dinner to find his office occupied by Alston and three other men, including Peter Michaels. Michaels informed Renfroe that Cox was in the building searching for Alston and that there was going to be trouble. Renfroe and his colleagues tried to calm the situation, but to no avail. According to Renfroe, Cox, who had been searching for Alston, burst into the office brandishing his pistol. Alston raised his hands in the air and began to plead with Cox, who would not be placated. As Alston made his way to the door, Cox followed some way behind him, pistol cocked. Recognizing an opportunity, Alston whipped out his own pistol, and the two men began firing wildly at each other. Cox's third shot hit Alston in the temple, and he died from the wound some hours later. Cox suffered only minor wounds and was tried for murder in Fulton Superior Court on May 7, 1879. His pleas for mercy went unheard, and he was found guilty and sentenced to Dade coal mines for life. He was pardoned in 1882 by Governor Alexander H. Stephens.

The convict leasing system became less popular during the early twentieth century, partly due to the election of Governor Hoke Smith and increasing media attention to the deplorable and inhumane conditions of convict leasing. It was never officially abolished but gradually transformed as plantation labor was replaced by the chain gang.

MORE EXPEDIENT TRIALS

In July 1879, Augustus O. Bacon, Speaker of the House of Representatives, presented a new bill before the house. Bacon's concern was that criminals were encouraged in their lawlessness by the belief that their crimes would go unpunished. Bacon believed that this was due to the frequent continuances of trials, which often led to a delay of between six months and three years before a trial could be heard. Bacon had seen many cases where such postponement often led to the jury acquitting the perpetrator, and he believed that more expedient trials would lead to more just outcomes.

Copycat Killer

The Atlanta Ripper

In 1888, the people of London, England, were shocked and terrified by a series of brutal and horrific murders, the likes of which had never before been seen. The victims were all women, most of whom earned a living as prostitutes. Each victim was killed in the same brutal manner, in which her throat was slashed so severely as to almost sever her head from her body. Most of the victims' bodies had also been mutilated; some had their internal organs removed. The murderer became known as Jack the Ripper. The murders rocked the British nation and made equally shocking news in the United States.

In 1911, a series of murders began in Atlanta that would not only terrify residents but also earn the perpetrator the title of the Atlanta Ripper. It is believed that the infamous Atlanta Ripper murdered and mutilated at least twenty black and mixed-race women, most of whom were young, attractive servant girls. The reign of crime lasted over a period of four years.

The first murder is believed to have taken place on January 22, 1911, on which date Rosa Trice was found killed near Gardner Street, with her head crushed and her throat slashed from ear to ear. Only a few weeks later, on February 19, 1911, an unnamed victim was found in the Grant Park area, killed in the same brutal manner. The murders then peaked in a frantic killing spree in the spring of that year, with a new body turning up every Sunday for several consecutive weeks.

SEGREGATION PROMPTS UNDERREPORTING

The Jim Crow laws, which had been in place since 1865, mandated segregation of blacks and whites in public places. This meant that black and white children could not be educated in the same schools and black and white people could not travel in the same sections of public transport, and even mandated that a black barber could not cut a white person's hair. The racial divide and its ensuing tensions may well account for the noticeable omission of reports of the Ripper's activities in the *Atlanta Constitution*. The *Constitution*, like the *Atlanta Journal* and the *Atlanta Georgian*, employed mainly white journalists at the time, and its circulation was predominantly throughout the white communities. It was not until the body of Belle Walker was found on May 29, 1911, that the *Constitution* mentioned the killings at all, and then the story was reduced to a brief paragraph on the seventh page.

THE VICTIM LIST CONTINUES TO GROW

Addie Watts was to be the next unfortunate victim. Like many of the victims, she was found close to the Southern Railway. She had been beaten about the head with a coupling pin and her throat had been cut. It wasn't until after Addie Watts had been slain that the local papers began to suggest that the murders might be the work of a single killer. Under the headline "Black Butcher at Work," the *Atlanta Constitution* ran a four-paragraph story connecting the killer's method to that of London's "Jack the Ripper," and the Georgia killer became known as "the Atlanta Ripper."

Dawn broke on the following Sunday to reveal Lizzie Watts's body dumped in some bushes at White and Lawton Streets.

POSSIBLE VICTIM SURVIVES

Though her mother wasn't so lucky, twenty-year-old Emma Lou Sharpe may have been one of the only surviving victims of the Atlanta

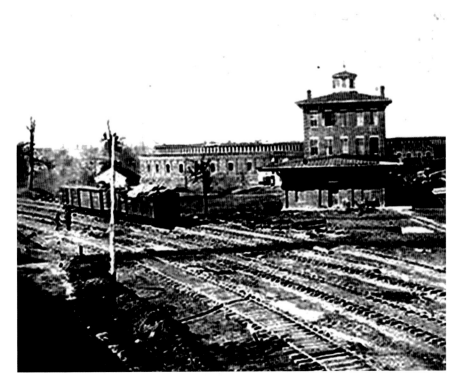

Atlanta railroad depot, late nineteenth century.

Ripper. On July 1, 1911, Emma Lou was at home on Hanover Street waiting for her mother to return from grocery shopping. Though Mrs. Lena Sharpe had only been gone for an hour, Emma was disturbed by the recent brutal killings and began to worry when night began to fall and her mother was still not home. Though young Emma Lou knew she was putting herself at risk by going out onto the street, she was more afraid for her mother and decided to go and search for her. When Emma Lou reached the market, she found out, to her horror, that her mother had never showed up there.

On her way home, Emma Lou encountered a stranger. According to the *Atlanta Constitution*, she described him as "tall, black, broad shouldered and wearing a broad-brimmed, black hat." The stranger asked Emma Lou how she was feeling, to which she replied, "I'm very well."

Assuming their conversation was over, Emma Lou attempted to walk past the man, but he blocked her path. "Don't be 'fraid," he

told her, "I never hurt girls like you." But no sooner had the words come out of his mouth than the stranger stabbed Emma Lou in the back. Bleeding profusely and screaming loudly, the young girl ran away. Soon, a crowd of neighbors gathered and she was taken to safety.

Fortunately, Emma Lou's life was saved. Her mother was not so fortunate; she was already dead by the time of her daughter's encounter with the stranger. Lena Sharpe was found later, her throat cut with such brutality that her head was almost severed from her body.

REWARD FOR INFORMATION

Following the murder of Lena Sharpe, Atlanta undertaker L.L. Lee offered a twenty-five-dollar reward for any information pertaining to the killings. This roused further interest among the press, and subsequent stories began to hit the news wires and reach newspapers in Ohio and New York.

Fear was by now gripping everyone's hearts throughout the local black community, and many people were dreading the coming Saturday in case the Atlanta Ripper would strike again. On the night of Saturday, July 8, everyone's worst nightmare came true. Twenty-two-year-old Mary Yedell almost became the next victim. Mary worked as a cook for W.M. Selcer, who resided on Fourth Street. On leaving the house to return home that Saturday night, Mary was approached by a tall, black stranger. Afraid for her life, Mary ran screaming back to her employer's house and alerted Selcer. Grabbing his revolver, Selcer ran into the alley, where he found the man standing in the shadows. When Selcer challenged him, the stranger disappeared into the darkness of the alley. Selcer alerted the police, who searched the alley and surrounding streets, but they were unable to locate the stranger.

A few days later, several local black churches increased the reward for the capture of the killer. Perhaps Mary Yedell had witnessed the Ripper and her quick action prevented another slaying that weekend, but the respite was not to last. On Tuesday morning, July 11, the body of twenty-year old Sadie Holley was found in a ditch near Atlanta Avenue and Martin Street. She was discovered

Late nineteenth-century housing in Atlanta.

by black laborer Will Broglin about 7:00 a.m. On his way to work, Broglin noticed signs of a struggle in the freshly graded earth. He found Sadie's body nearby. Like the other victims, Sadie's head had been smashed and her throat had been viciously slashed. A large stone covered in blood was found in a nearby field. Her missing shoes were never found.

POLICE MAKE AN ARREST

On July 12, the day after Sadie Holley's murder, the police arrested twenty-seven-year-old black laborer Henry Huff at his home on Brotherton Street. Witnesses claimed to have seen Huff with Sadie Holley during the previous evening. According to the *Constitution*, when he was arrested, Huff's trousers were covered in dirt and blood.

Huff had a wound on his head, which he had sustained in a poolroom fight. He claimed that this was the source of the blood on his clothes. Police also found suspicious scratches on Huff's arms, which appeared to have been made by fingernails.

Some days later, a second arrest was made. Thirty-five-year-old Todd Henderson was detained after being identified by Emma Lou Sharpe, the girl who had been stabbed on Hannover Street some weeks before. The police had been looking for Henderson for some time, but he had managed to elude detectives. However, although Emma Lou viewed Henderson in the dark and the light and also got to hear his voice, when asked if he was the man who had attacked her she could only say, "To the best of my knowledge." This was not considered a positive identification. According to the *Constitution*, Emma Lou's partial identification was supported by a witness statement made by a clerk who worked in a grocery store near the area of Hannover Street where the assault took place. Henderson was also seen that night in a nearby drugstore with Sadie Holley. He was further implicated by circumstantial evidence when police discovered that his shoe fit the print that had been left behind at the crime scene of Sadie Holley's murder. In a moment of bravado, Henderson told the police that if he intended to kill anyone, his wife would already be dead. It was reported that Henderson had a history of violence toward his wife, and on the night he had been arrested in a Decatur street, he was spying on her as she visited a friend. Though Henderson denied owning a razor or knife for more than a year, police discovered that the day after Sadie's murder he had taken a razor to a local barbershop to be sharpened.

Simultaneous Crime Wave

While the black community was living in fear for the lives of its young women, the white community was suffering a different crime wave of its own. In the more affluent sections of the city, there was an ongoing series of robberies, in which several thousands of dollars' worth of jewels and family heirlooms were stolen. The police believed the robberies to be the work of a gang, though its identity was unknown. The press juxtaposed the two series of crimes, often in the same

article, almost as though they were on the same level of seriousness, and perhaps in some eyes they were. The police certainly seemed to be overwhelmed by trying to keep up with both a gang of robbers and a serial killer.

Afraid that the cutthroat killer was becoming more audacious in his crimes and disgusted that the Atlanta Police Department could not offer any explanation for its failing to track down the killer, people in the local black community appealed to the mayor and governor to help put an end to the series of heinous crimes once and for all by offering rewards. A petition promoted by several black ministers, including Reverend Henry Hugh Proctor, was circulated throughout the city and was backed by a large number of black and white residents. On July 12, 1911, the *Atlanta Constitution* printed a copy of the petition, which read:

> *Within the last two years seventeen colored women have been found murdered in this community as follows:*
>
> *April 5, 1909. Della Reid, found dead in trash pile near 71 Rankin Street.*
> *September 7, 1909. unknown, found dead in Peachtree creek.*
> *March 5, 1910. Estella Baldwin, 735 North Jackson street, concussion of brain.*
> *April 5, 1910. Georgia Brown, 167 Martin street, gunshot wound.*
> *April 6, 1910. Mattie Smith, 141½ Peters street, gunshot wound.*
> *May 6, 1910. Lavinia Ostin, gunshot wound.*
> *May 23, 1910. Sarah Dukes, 119 Curran street, gunshot wound.*
> *Francis Lampkin, 407 Foundry street, gunshot wound.*
> *September 4, 1910. Eliza Griggs, 28 Dover street, gunshot wound.*
> *October 6, 1910. Maggie Brooks, East Ellis street, killed on Hill street, near West Point and belt line.*
> *February 3, 1911. Lucinda McNeal, 92 Spencer street, throat cut.*
> *May 8, 1911. Rosa L Rivers, 122 Randolph street, shot.*
> *May 29, 1911. Mary Walker, 228 Garibaldi street, throat cut.*
> *June 15, 1911. Addie Watts, 30 Selman street, throat cut.*
> *June 27, 1911. Lizzie Watkins, West Oakland street, throat cut.*
> *July 2, 1911. Lena Sharp, 24 Hanover street, throat cut.*
> *July 10, 1911. Sadie Hollis, killed on Gardner street, throat cut.*

As far as we can ascertain there had been no conviction for any one of these murders and very few, if any, arrests.

We, therefore, petition you to offer a suitable reward for the apprehension and conviction of these unpunished murderers who have produced a state of terror in the community.

Who Is the Real Ripper?

Despite the fact that most of the evidence against the two suspects—Henderson and Huff—was circumstantial, the authorities handed both men over to the prosecutor with hopes that a jury would decide which was the infamous killer. They showed little confidence in their own convictions, however, because they continued to patrol the streets at night, and even while both men were in custody they continued to make arrests. A third man named John Daniel was also indicted, though the press revealed little information about the man other than the fact that he was a Ripper suspect.

Suddenly, the murders stopped. Almost seven weeks went by without a Ripper killing. Then, on August 31, the *Atlanta Constitution* broke the news that the body of twenty-year-old Mary Ann Duncan had been found near some railway tracks just west of Atlanta. Like Sadie Holley, Mary Ann was found with her throat cut and her shoes missing.

The murders continued throughout the fall, and the police soon realized that they did not have the real Ripper in custody. Mary Ann Duncan's demise was followed closely by that of Minnie Wise, a young mixed-race woman whose throat had been slashed from ear to ear and was also missing her shoes. In a new twist, Minnie's right-hand index finger had been severed at the middle joint.

By now, news of the Atlanta Ripper was rolling hot off the presses throughout the country. Chief of Police Henry Jennings made a public explanation for the inadequacy of his department, stating that the small size of the police force was causing a severe handicap. Much to the embarrassment of Mayor Cortland S. Winn and the Atlanta Police Department, this was followed up with messages from detectives in other cities offering their services. Mayor Winn defended the Atlanta Police Department with the true pride he felt it deserved and answered the detectives' letters by assuring them that Atlanta's

authorities were second to none. But his pride must have been deflated only a week later when Atlanta awoke to the most gruesome Ripper murder so far. According to the *Atlanta Constitution*, an unidentified woman's body was found with her head almost completely detached from her body. She had been disemboweled and her heart had been cut out and placed by her side.

Local black churches immediately urged the female members of their congregations to stay home at night and continued to raise funds to increase the reward for the Ripper's capture. Reverend Proctor continued to press the mayor and the governor for black detectives to help liaise with the local community, to no avail. Meanwhile, Henry Huff and Todd Henderson were found not guilty by jury. The *Atlanta Constitution* later reported that the grand jury had concluded that there was no single serial killer responsible for all of the killings, but that they each had an individual perpetrator. They added that the crimes themselves stemmed from individual "immoral conduct." The paper offered no explanation as to how the jury had reached its conclusion.

Less than a month later, the same paper announced that the Ripper had claimed his nineteenth victim. This time, the nineteen-year-old mixed-race girl was found in some bushes at the corner of Pryor Street. She had been stabbed in the throat a number of times. This murder was closely followed by the slaying of a fifteen-year-old girl whose mutilated body was found floating in the Chattahoochee River.

Throughout the spring of 1912, the police continued to arrest a series of suspects. Eventually, Atlanta man Charlie Owens was tried and sentenced to life in prison for one of the Ripper murders. Though the papers reported the sentencing, they did not mention which murder Owens was found guilty of. The killings continued.

In August of the same year, Atlanta police finally believed that they had caught the killer. Atlanta man Henry Brown, also known as Lawton Brown, was arrested for the murder of Eva Lawrence, which had taken place a year previously. When questioned, Brown's wife told the police that he had frequently returned home on Saturday evenings with his clothes saturated in blood. Brown himself seemed to know a number of undisclosed details about several of the murders. However, when Brown went to trial, a man named by the *Atlanta Constitution* as John Rutherford testified in Brown's defense, saying that police had brutally beaten a confession out of him. Brown was acquitted on October 8, 1912.

THE RIPPER TAUNTS AUTHORITIES

Despite its continued efforts, the Atlanta Police Department was unable to pin down the murderer. In 1913, the killings had slowed down to three, ending with the killing of Laura Smith, a young mixed-race servant girl who, like her precedents, had her throat cut. Then the three-year-old case took a different turn in 1914. Like many serial killers since, the Atlanta Ripper appeared to take pleasure in taunting the authorities. He did so by posting a trail of cards on fireboxes throughout the city. The notes renewed fear with their threats to "cut the throats of all negro women" on the streets after dark.

The last reported murder in connection with the Ripper was that of twenty-five-year-old Mary Roland on July 22, 1914. Her body was found in a treed area on Hill Street, where she was half submerged in the creek. She had been shot in the head, and her throat and breast had also been slashed. Footprints were found in the damp earth surrounding the body. Eight days later, the *Atlanta Constitution* reported the arrest of Henry Harper as a "Jack the Ripper" suspect.

ANOTHER TWIST IN THE TALE

Despite the fact that the police had a number of suspects based on physical clues and eyewitness statements, and made several arrests, the killer was never identified, and no arrest was ever made for any of the other killings. In an interesting twist to the case, during the trial of Leo Frank for the killing of Mary Phagan in 1913, detective W.J. Burns stated that he had proof that suspect Jim Conley was not only guilty of the murder of Mary Phagan, but was also the Atlanta Ripper. Nothing ever came of these claims, however.

Whether the so-called Ripper murders were the act of a serial killer or a number of copycat killers will never be known for sure. Today, there remains too little documentation or evidence to reach a conclusion.

A CASE OF DOUBT

The Murder of Mary Phagan

In 1913, the South was at last beginning to recover from General William T. Sherman's destructive march through the Confederacy. Slowly and steadily recovering from its decimation during the Battle of Atlanta, the city had begun to rise like a phoenix and was becoming one of the more prominent southern cities. By 1910, the population of Atlanta was 154,839, 33.5 percent of whom were black. The Georgia Railway and Electric Company had been formed eleven years earlier and, more recently, taxicabs had been introduced to the city. Business was booming, and one important cog in the economic machinery was the National Pencil Factory. The factory was owned by prominent Jewish businessmen, the majority shareholder being Sig Montag, owner of the Montag Paper Company.

MURDER SHOCKS ATLANTA

In April 1913, a tragic and horrendous event occurred that not only shook Atlanta and the state of Georgia, but many other states throughout the country as well. That event was the death of thirteen-year-old Mary Phagan, who was brutally murdered at the National Pencil Factory at 37–39 Forsythe Street, her place of employment.

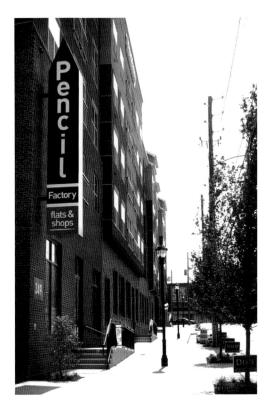

The original site of the National Pencil Factory, now converted into lofts. *Photograph by Lance Haugan.*

Mary Phagan was a pretty girl, the youngest of five siblings, only a month away from her fourteenth birthday. She had worked at the National Pencil Factory for almost three years. She was employed in the second-floor metalwork room, where she operated a machine that placed the metal tips on pencils, though she had not worked since the previous Monday because the factory was awaiting a delivery of metal tips. Mary was known as a lively and kind girl and had many friends both at the factory and outside.

April 26, 1913, was Confederate Memorial Day, a public holiday commemorating the veterans and fallen soldiers of the Southern army. The morning turned out to be fine, and after eating lunch with her family, Mary left her home on Lindsey Street at 11:45 a.m. She caught the East Point streetcar and headed to the factory to collect her $1.20 wages. Wearing a new dress and carrying her parasol and purse, Mary was in good spirits and was planning to meet friends in the city to watch the Memorial Day parade and then perhaps catch a movie at the Bijou Theater.

When Mary did not arrive home that evening, her grandmother, Fannie Coleman, began to worry. Fannie's husband went downtown to look for Mary in the hope that the young girl had stayed to watch a late show. He waited outside the theatre for several hours and searched Mary's known haunts. When he couldn't find her, he returned home and began knocking on neighbors' doors. No one had seen Mary. It was not until the next morning that Helen Ferguson, one of Mary's friends and a co-worker, showed up at the house to tell them that she had received the shocking news that Mary's dead body had been found at the Pencil Factory.

What is known for certain is that Mary arrived at the factory around noon and went to plant supervisor Leo Frank's office to collect her salary. The events that followed can only be described based on numerous witness statements and court testimonials, many of which are both confusing and contradictory.

A GRUESOME DISCOVERY

On the morning of April 27, shortly after 3:00 a.m., night watchman Newt Lee discovered the body of a girl in the factory's basement. The girl would later be identified as Mary Phagan. Lee immediately called the police and then called the factory supervisor Leo Frank.

When the police arrived at the factory and examined the body, they discovered that the girl was so covered in ash and pencil shavings that they could not discern for certain that she was a white girl until they pulled down one of her stockings and saw her leg.

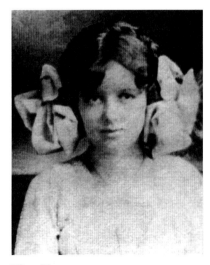

She had a 1 ½-inch gash on the side of her head and had been strangled by a cord that was embedded in her neck. Her underwear was torn and bloody. Her mouth and nose were full of ash, and she appeared to have been dragged face down across the basement floor. On a pile of sawdust

Mary Phagan.

at the back of the room lay her hat and, nearby, one of her shoes. Two poorly handwritten notes, scrawled on National Pencil Factory order sheets, were found in the dirt beneath the body. The notes read:

> *Mam that negro hire down here did this i went to make water and he push me doun that hole a long negro black that hoo it was long sleam tall negro i wright while play with me.*

> *He said he wood love me and land doun play like night witch did it but that long tall black negro did by his self.*

Because of the presence of the notes and the mention of "night witch," or night watchman, suspicion was immediately cast upon Newt Lee, who was arrested and placed in jail.

The press went to town with the news of the murder. The public hysteria that followed had already been kindled by a series of murders that had occurred throughout the city between 1909 and 1912 by a killer who came to be known as the Atlanta Ripper. Although the newspapers had initially given little coverage of the serial killings, they began to feed public frenzy with daily reports and extras of Mary Phagan's murder and the trial that followed. The *Atlanta Constitution* broke the story about Mary Phagan's murder, followed closely by the *Georgian*. The two papers competed fiercely to be first to print breaking news. Some days, as many as forty extra editions rolled off the presses.

Newt Lee's Statement

Newt Lee had been working at the National Pencil Factory for only three weeks. On the afternoon of April 26, at 4:00 p.m., he showed up for duty an hour earlier than usual at the request of his boss, Leo Frank. Frank had said that he wanted to leave early to attend a baseball game. Upon his arrival, Lee was surprised to find that although the street doors were unlocked as usual, the inner doors had been locked. When Lee reached the second floor, Frank came out of his office and appeared flustered and nervous. He asked Lee to go downtown and return again at 6:00 p.m. Lee duly returned at

the allocated time, after which Frank left to go home for dinner and did not return again that night. Frank called the factory at 7:00 p.m. to ask if everything was all right, something that Lee claimed his boss had not done before.

Lee denied the murder and explained that he had found the body when he went down to the basement to use the toilet. Despite the incriminating notes, Lee's story was plausible, and he did not change it under examination.

Suspicion Turns

On Monday, April 28, 1913, R.P. Barrett, an eighteen-year old machinist at the National Pencil Factory, noticed a strange-looking red spot on the metal shop floor, close to the women's dressing room. The crimson spot was about twenty feet from where Mary Phagan's workstation had been. It was about five inches in diameter and was surrounded by smaller spattering. It appeared to be blood. Barrett also claimed that it seemed as though someone had tried to hide it by covering it with a white substance that may have been Haskoline. Though the medical examiner, Dr. Claude Smith, did confirm that the substance was blood, he could not say with any accuracy how long the blood had been on the floor. Several co-workers reported that small amounts of blood were often present on the metal room floor, caused by minor, work-related injuries. The prosecution, however, would later use the blood spatter as evidence that Leo Frank had murdered Mary Phagan in the metalwork room.

Frank himself was dissatisfied that the authorities were not doing enough to find the culprit. He personally brought in a detective from the Pinkerton Agency to help with the investigation on April 28. The detective was unable to help the case much, and further suspicion began to fall on Frank after an inquest into Mary's death that took place in April 30, during which George Epps, a former friend of Mary's, claimed that she had confided in him that she was afraid of Frank because he had flirted with her and made advances on a number of occasions.

THE ARREST OF LEO FRANK

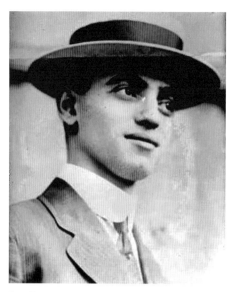

Leo Frank.

Born in Paris, Texas, on April 17, 1884, Leo Frank later moved with his parents to Brooklyn, where he was raised with a conventional Jewish middle-class upbringing. He graduated from Cornell University in 1906, and shortly after, his uncle, Moses Frank, invited him to move to Atlanta, where he became an investor in and supervisor of the National Pencil Factory. In 1910, Frank married Lucile Selig, daughter of a prominent Atlanta Jewish businessman, and he soon developed a reputation as a respected member of the Jewish community.

The superintendent of the National Pencil Factory had to be questioned as a matter of course. Despite the fact the police telephoned Frank several times on the morning of April 27, they were unable to get an answer, and when they arrived at his house he was still in bed. When he dressed and came down to talk to the police, they found his demeanor agitated and nervous, which immediately aroused their suspicion. When they questioned him about Mary Phagan's visit to the factory the previous day, he initially denied any knowledge of it. Later, at the factory, Frank checked his time book and this seemed to jog his memory. He admitted that she had come to the office the previous day to collect her wages.

Frank told the police that he had been at the factory all day on the day of the murder. He had arrived at 8:30 a.m., gone to Montag Brothers at 9:40 a.m. and had returned to the factory about 10:55 a.m. From that time, he had remained in his office until 12:45 or 12:50 p.m., when he had gone home for lunch. He returned at 3:00 p.m. and stayed at the factory until 6:00 p.m., at which time he went home for dinner and remained there for the rest of the night. Frank told the police that his stenographer had left the office at noon and

that shortly after this, the office boy, Alonzo Mann, also left. Mary came in just after, collected her money and left.

Medical examiner Dr. Henry Harris reported that the contents of Mary's stomach showed that she had eaten between a half to three-quarters of an hour before she died, which put her time of death between 12:15 and 12:30 p.m. Though Frank claimed to be in his office at the time of the murder, upon further investigation he seemed unable to account for his whereabouts between the times of 12:00 and 12:30 p.m. Worker Monteen Stover claimed to have visited the office to collect her wages at 12:05 p.m. to find Frank absent. Stover said that she had waited about ten minutes for Frank to return, and when he did not, she left. On May 8, 1913, Leo Frank was held in custody by the Atlanta Police on a charge of the murder of Mary Phagan. The newspapers placed great emphasis on Frank's supposed nervousness during his interview with the police, which caught the public's attention and roused their suspicion.

THE TRIAL BEGINS

The trial began on July 28, 1913. Judge Leonard S. Roan strove to maintain order in the court despite the many unruly spectators who displayed open animosity toward Frank. Solicitor General Hugh M. Dorsey, the prosecuting attorney, submitted to the court that Leo Frank had a secret meeting upstairs with Mary Phagan and that he had killed her in the metalwork shop, near the dressing room. Dorsey submitted that Frank had then ordered Jim Conley, a twenty-seven-year-old sweeper at the factory, to help him dispose of the body and to write the two death notes that were intended to incriminate the night watchman, Newt Lee. Dorsey claimed that Conley had followed Frank's instructions because he was loyal to his boss, but he did not return that night to dispose of the body because he did not want it on his conscience. Jim Conley was the key prosecution witness, and it was his testimony that ultimately sealed the fate of Leo Frank.

Attorney Luther Z. Rosser was directing Frank's defense. Rosser was an experienced trial lawyer with an excellent reputation. Rosser claimed that Conley had committed the murder and was trying to frame Frank. In an attempt to counter the prosecution's charges of

sexual immorality, Rosser called a number of witnesses to testify to Frank's impeccable character. He also tried to establish a tight alibi for Frank during the time of the murder. Frank stood well under examination, and the prosecution was unable to prove any discrepancies. The weakness in Frank's defense, however, was that he had a gap of between twenty and thirty minutes in his alibi, during which time he could not prove his presence in the office.

SUSPICION FALLS ON JIM CONLEY

James Conley was arrested on May 1, 1913, after being discovered rinsing blood from a shirt at the National Pencil Factory. Little was known about the man other than the fact that he had a poor work record and he had been arrested on several occasions for drunk and disorderly conduct. Initially, Conley was free from suspicion because he claimed that he could not write and therefore could not have been the author of the murder notes. However, Conley was to change his story a number of times until he later admitted that he helped Frank carry Mary's dead body to the basement, and that once there, Frank made him write the murder notes.

Conley claimed that Frank had asked him to come to the factory to watch for him, as he had on many occasions, while he had a rendezvous with a woman. According to Conley, he and his employer had an established code whereby Frank would stamp his foot to signal for Conley to lock the factory door when the woman was inside. He would then whistle when he wished it to be reopened so that the woman may leave. Meanwhile, Conley would hide behind some boxes near the stairs where he would not be seen.

Conley claimed that on the day of the murder, several employees passed him on their way to Frank's second-floor office. He also said that Mary Phagan went up the stairs and a few minutes later he heard footsteps to the metal room. After a while, he dozed off for a few minutes until he was woken by Frank stamping on the floor, at which point he locked the door. At the sound of Frank's whistle, some time after, Conley reported that he unlocked the door and went upstairs, where he saw Frank coming out of his office looking shaken, holding a small rope and a cord.

A Case of Doubt: The Murder of Mary Phagan

Jim Conley said that he saw Mary Phagan lying on the metal room floor with a rope tied around her neck and a cloth under her head as though to catch blood. Frank told him that the girl had refused his advances, so he had struck her and she fell and hit her head.

Under Frank's instruction, Conley said that he rolled the body in a cloth and tied her up. Because he was unable to carry her alone, Frank supported her feet and the two of them took her down to the basement via the elevator. Frank then dictated the notes to Conley and gave him $200 to keep quiet. Frank then took the money back and told Conley that he could have it back providing he came back that night and burned the body. However, Conley went drinking after he left the factory and then went home to bed, where he fell asleep. He claimed that he did not return to the factory that night.

The prosecution pounded Frank's character, bringing more than thirty female witnesses and workers from the National Pencil Factory, each of whom testified that Frank had spoken to or touched them in an inappropriate manner. A number of other witnesses claimed to have seen Frank talk to Mary and on occasion seen him touch her. The witness testimony raised the wrath of the onlookers in the courtroom, and the press used them to fuel public fervor.

Public opinion of Frank was becoming increasingly volatile. Already despised for being the manager of a sweatshop, he was now also viewed by many in the non-Jewish community as a lascivious philanderer. Many of the detectives involved concentrated their efforts on tracking down further reports of Frank's alleged sexual advances toward other female factory workers.

Within the Jewish community, support for Frank was strong. Determined to emphasize his respectable reputation, many eminent figures within the community began elucidating Frank's upstanding character, emphasizing his Cornell education, his devotion to his wife and the fact that he was president of B'Nai Brith. More than forty of the one hundred female workers at the factory testified to Frank's honesty and moral character.

Tom Watson, publisher of the *Jeffersonian*, made no pretense of hiding his sentiments against Leo Frank. In a number of vitriolic editorials, he not only condemned Frank as a sexual pervert but also accused the Burns detective agency of perverting the cause of justice by threatening and bribing witnesses to give testimony in his defense.

THE TRIAL TAKES A SHOCKING TURN

The trial took a sensational turn with the reading of Annie Maude Carter's affidavit. Carter had recently become engaged to John Conley, and she now claimed that while in prison, he had confessed to Mary Phagan's murder to her in return for her hand in marriage. Carter reported that Conley had been sitting beneath the stairs when Mary came down. He then struck her, kicking out, and dropped her body through the trapdoor down to the cellar. Conley allegedly told his fiancée that he had intended to burn the body but had a fit of conscience and could not go through with it, so he had written the notes instead. The prosecution counteracted this affidavit with testimony from another convict. They accused Burns detective agent Jimmy Wren of coercing Carter into framing Conley. Conley himself denied the confession, and the judge ruled that the Carter affidavit be expunged from the trial.

This was followed by a controversial affidavit from Baptist minister Reverend C.B. Ragsdale, in which he claimed to have overheard Conley confess to Mary Phagan's murder to another man in an alley a few days after the murder. A devout and respected member of the congregation, R.L Barber, supported Ragsdale's statement, claiming that he had been with the minister on the night in question. However, within a few days, Ragsdale had withdrawn his affidavit, explaining that he had been approached by two anonymous detectives from the Pinkerton Agency who had offered him money to make the statement. Though W.J. Burns, the lead detective from the Pinkerton Agency, denied the claims, Ragsdale's original statement was also struck from the record.

This attack on the detectives led to later charges of subordination of perjury in an attempt to obtain a new trial for Frank. These charges were brought against Dan S. Lehon, southern manager of the Burns detective agency; former Burns operative C.C. Tedder; and attorney Arthur Thurman. On January 13, 1915, a jury found the three not guilty. Despite the verdict in their favor, this did not completely dispel rumors that large sums of money had been exchanged with the intent to corrupt justice in the Leo Frank trial.

Frank's Sentence

Leo Frank was finally declared guilty at 4:55 p.m. on August 23, 1913, the twenty-fifth day of the trial. Three days later, Judge L.S. Roan sentenced Frank to hang. The original date was set for October 10, 1913.

Frank's attorneys motioned for a new trial, which was duly denied but caused the hanging to be rescheduled until April 17, 1914. Eleven days before his scheduled execution, Frank's attorneys motioned to set aside the guilty verdict in the Fulton County Superior Court, and his execution was rescheduled once again for January 22, 1915. The motion was denied, and Frank's attorneys appealed to the Georgia Supreme Court, where the request for a new trial was once again denied. Frank's execution was finally rescheduled for July 22, 1915. On June 15, 1915, Georgia governor John Slaton commuted Frank's sentence from death to life in prison and ordered that Frank be transferred from Fulton County prison to the Milledgeville Prison Farm, for fear that a lynch mob may overpower the prison guards. Frank was transferred during the middle of the night just six days later.

The transfer proved not enough to keep Frank out of harm's way. On August 16, 1915, eight vehicles bearing twenty-five armed men from Atlanta arrived at the Milledgeville Prison Farm about 10:00 p.m. The self-appointed Knights of Mary Phagan cut the telephone lines and overpowered the guards. They seized Frank and took the back roads home to Marietta. They stopped during the early hours of the following morning at Fray's Grove, not far from Mary Phagan's childhood home, and hanged Frank from a tree. Crowds gathered and photographs were taken of Frank's hanging body, one of which became a souvenir postcard. That night, Frank's body was taken down, embalmed and taken by train to Brooklyn's Mount Carmel Cemetery, where a burial service was held.

Jim Conley was sentenced to a year on a chain gang on February 24, 1914, for his role in Mary Phagan's murder.

No one was ever tried or prosecuted for the murder of Leo Frank.

EVIDENCE WITHHELD

In 1922, Pierre Van Passen began reporting for the *Constitution*. On reexamining the Fulton County Courthouse records of the case, he discovered photographs of teeth marks on Mary Phagan's body along with dental X-rays taken of Leo Frank. The two did not match. He became convinced that, had the photographs not been withheld at the time of the murder, Frank would have been found innocent. Van Passen obtained the editor's permission to run a story that would prove Frank's innocence. However, after anonymous threats and an attempt on his life, the young reporter decided to forget the story.

ALONZO MANN COMES FORWARD

Astonishingly, in 1982, Alonzo Mann, who had been an employee at the National Pencil Factory at the time of the murder, claimed that he had seen Conley carrying Mary's body at the factory on the day of the murder. Mann said that he did not admit it at the time because Conley had threatened to kill him if he breathed a word about what he had seen. Fear for his life kept Mann quiet for almost seventy years.

Mann confessed that he arrived at 8:00 a.m. on the day of the murder and that Conley was sitting under the stairwell. He was already drunk and tried to beg a dime from Mann to buy more beer. The young boy refused and went to Frank's office, where he worked. Frank arrived shortly after. Mann claimed that he left just before noon without seeing Mary, whom he knew by face. When he left, Conley was still sitting under the stairs. When his mother did not turn up to meet him for the parade, Mann returned to the factory, where he saw Conley standing between the trapdoor and the elevator shaft with a girl's body in his arms. Although she seemed unconscious, Mann claims that he saw no blood. Conley threatened to kill Mann if he didn't forget what he had seen. The youth rushed home and told his parents, who advised him to remain silent, which he did for almost seventy years. Although Mann's admission conflicts with Conley's story and proves that he hid the body, it is still not enough to prove Frank's innocence.

LEO FRANK'S PARDON

Many people today still think that the Leo Frank trial was a blatant miscarriage of justice that highlighted prejudices and fears that were rife in the South at the time. These included workers' resentment about being exploited by northern factory owners and circulating anti-Semitism, both of which were exacerbated by the press's biased and often misleading accounts of the trial.

In 1983, a petition for a posthumous pardon for Frank was denied. In 1986, the Georgia State Board of Pardons and Paroles pardoned Frank, stating:

> *Without attempting to address the question of guilt or innocence, and in recognition of the State's failure to protect the person of Leo M. Frank and thereby preserve his opportunity for continued legal appeal*

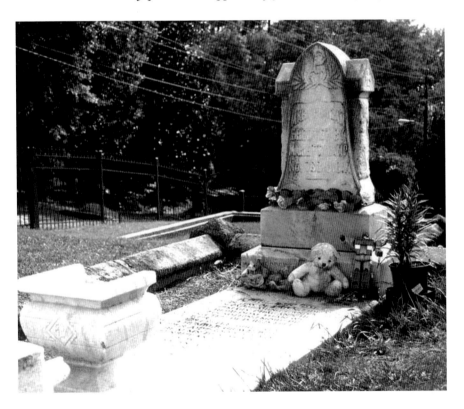

Mary Phagan's grave. *Photograph by Lance Haugan.*

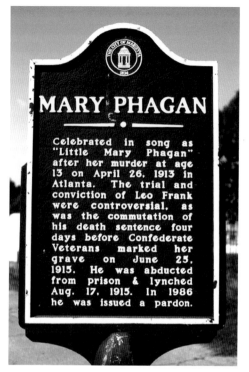

Mary Phagan historical marker.
Photograph by Lance Haugan.

of his conviction, and in recognition of the State's failure to bring his killers to justice, and as an effort to heal old wounds, the State Board of Pardons and Paroles, in compliance with its Constitutional and statutory authority, hereby grants to Leo M. Frank a Pardon.

The case has continued to hold fascination and has inspired a number of academic, historic and legal commentaries and analyses. It has also been interpreted through visual media, including a made for TV movie entitled *The Murder of Mary Phagan* in 1988 and a Broadway musical entitled *Parade*, first performed in 1999.

A Case of Doubt: The Murder of Mary Phagan

THE BALLAD OF MARY PHAGAN

by Franklyn Bliss Snyder
from The Journal of American Folk-Lore 31 (1918), 264–66

Little Mary Phagan
She left her home one day;
She went to the pencil-factory
To see the big parade.

She left her home at eleven,
She kissed her mother good-by;
Not one time did the poor child think
That she was a-going to die.

Leo Frank he met her
With a brutish heart, we know;
He smiled, and said, "Little Mary,
You won't go home no more."

Sneaked along behind her
Till she reached the metal-room;
He laughed, and said, "Little Mary,
You have met your fatal doom."

Down upon her knees
To Leo Frank she plead;
He taken a stick from the trash-pile
And struck her across the head.

Tears flow down her rosy cheeks
While the blood flows down her back;
Remembered telling her mother
What time she would be back.

You killed little Mary Phagan,
It was on one holiday;
Called for old Jim Conley
To carry her body away.

He taken her to the basement,
She was bound both hand and feet;
Down in the basement
Little Mary she did sleep.

Newtley was the watchman
Who went to wind his key;
Down in the basement
Little Mary he did see.

Went in and called the officers
Whose names I do not know;
Come to the pencil-factory,
Said, "Newtley, you must go."

Taken him to the jail-house,
They locked him in a cell;
Poor old innocent negro
Knew nothing for to tell.

Have a notion in my head,
When Frank he comes to die,
Stand examination
In a court-house in the sky.

Come, all you jolly people,
Wherever you may be,
Suppose little Mary Phagan
Belonged to you or me.

Now little Mary's mother
She weeps and mourns all day,
Praying to meet little Mary
In a better world some day.

Now little Mary's in Heaven,
Leo Frank's in jail,
Waiting for the day to come
When he can tell his tale.

A Case of Doubt: The Murder of Mary Phagan

Frank will be astonished
When the angels come to say,
"You killed little Mary Phagan;
It was on one holiday."

Judge he passed the sentence,
Then he reared back;
If he hang Leo Frank,
It won't bring little Mary back.

Frank he's got little children,
And they will want for bread;
Look up at their papa's picture,
Say, "Now my papa's dead."

Judge he passed the sentence
He reared back in his chair;
He will hang Leo Frank,
And give the negro a year.

Next time he passed the sentence,
You bet, he passed it well;
Well, Solister H.M.
Sent Leo Frank to hell.

Unsolved

The DeFoors Murders

The Chattahoochee River runs through the Appalachian Mountains from the Chattahoochee Spring, southwestward through the Atlanta suburbs and then winds its way south to form the southern border between Georgia and Alabama. The name Chattahoochee is believed to be derived from the Creek Indian term meaning "painted rock." This may indeed refer to the numerous granite outcroppings that color the northeast to southwest portion of the river.

The town of Standing Peachtree was located at the confluence of the Chattahoochee River and Peachtree Creek. The area was originally occupied by the Creek Indians, who were intolerant of Americans. On the opposite bank of the river lived the Cherokee.

March 1914 saw the arrival of American soldiers at Standing Peachtree. Under the command of James McConnell Montgomery, a fort was built on a small knob overlooking the confluence of the Chattahoochee and Peachtree. The project was intended to build boats to transport supplies downriver to Fort Mitchell, where troops were fighting Creek Indians in Alabama. Fort Peachtree became the first non-Indian settlement in north Georgia and was described by Sergeant James McConnell Montgomery, one of the soldiers under Gilmer's command, as providing a "romantic" view of the river.

MONTGOMERY'S FERRY

During the early nineteenth century, there were a number of ferries around the Atlanta area. Flatboats were used to transport traders across the river, and they became the first viable business in the northern part of Georgia. When, in 1821, the Creek ceded the land, Henry and Fayette Counties were created within the Atlanta area. Later, when the Cherokee were removed from the opposite side of the river, the northern area east of the Chattahoochee was ceded to DeKalb County. James McConnell Montgomery moved with his family to Standing Peachtree in 1819. He paid $100 for one thousand acres at

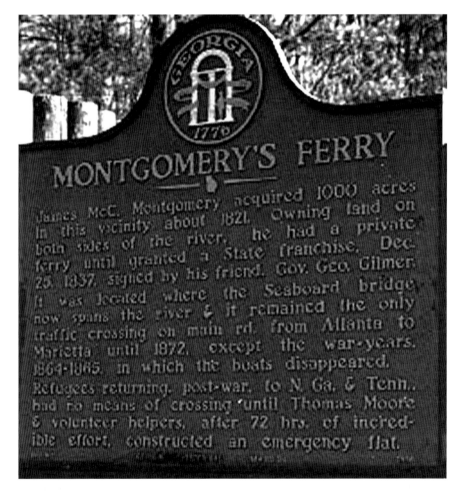

Montgomery's Ferry historical marker.

the site of the river crossing. There, he built and started a private river crossing known as Montgomery's Ferry. It was an ideal crossing point on the river, and locals would use it frequently to transport livestock and supplies from bank to bank. This was the only means of crossing the river at the time, so it provided a valuable service to the growing community and a good living was to be made. Montgomery and his family remained in Standing Peachtree, where he continued to hold a number of public positions, including postmaster, justice of the peace, tax collector and census taker, until his death on October 8, 1842. Martin DeFoor took over the ferry in 1853.

A Gruesome Murder

Martin DeFoor was born and raised in Franklin County, Georgia. On September 14, 1830, he took Susan Tabor as his wife. Within the next ten years, the couple moved to DeKalb County, where they settled into the Panthersville district. In 1853, the DeFoors moved to the old Montgomery home at Bolton (then known as Iceville), where DeFoor took over the old Montgomery's Ferry and renamed it DeFoor's Ferry.

The DeFoors continued to operate the ferry until the Civil War, when the ferry was used by Confederate soldiers until they were forced south by the opposition and the ferry was cut loose. When the war was over, the DeFoors' son-in-law, Thomas Moore, along with a number of locals, built a temporary crossing on the site of the former ferry. This was to allow the Confederate soldiers on the south side of the river reach their families in north Georgia and Tennessee. The crossing was built in a record-breaking time of seventy-two hours. A more permanent ferry was rebuilt later, and the DeFoors continued to run the crossing until the fateful night of July 25, 1879, when they were brutally murdered while they slept in their bed.

Some six miles outside the city, the old-style, two-story DeFoor homestead could be seen from the Iceville road. On the rainy Friday night of July 26, 1879, as they lay sleeping, Martin and Susan DeFoor became victims of a gruesome murder that has never been solved.

The DeFoors' bodies were found at 6:00 a.m. on the morning of July 26, 1879, by grandson Martin Walker. Having noticed that his

grandparents were not up and about at their usual time, he went to investigate. He found that the back door was open and the metal bolt that locked the door from the inside was lying on the ground outside. On entering the house, he found his own axe, which he had left in his woodpile the day before. The axe was lying in the fireplace covered with blood and ashes. He then found Mr. and Mrs. DeFoor in their bed. They had been almost decapitated by axe blows, and there were no visible signs of resistance.

A Few Clues

The side door to the house was still fastened, but all the other doors to the house were open. Although a bureau draw had been broken into, several valuable items, including a bag containing eighteen dollars in silver, had been left unmolested. Martin DeFoor's wallet, which contained only promissory notes and tax receipts, and his leather boots were the only items taken.

The house was composed of four rooms on the ground floor: two bedrooms, a parlor and the kitchen. The couple occupied the front bedroom. The DeFoor house also contained a small attic room accessible only by ladder. The DeFoors rarely used the attic. During the sheriff's investigation, it was discovered that someone had been occupying the room. The counterpane on the bed was ruffled and the indentation of a human form could be seen clearly, as could a muddy human footprint. Investigators also found some fresh human excrement containing watermelon seeds in an adjoining lumber room.

Walker calculated that the intruder must have gained entrance to the house sometime during the previous day while the DeFoors were out of the house milking the cows; he must have hidden in the attic room until the occupants were sleeping soundly. After committing the heinous act, he most likely snuck out the back door, which had been unlatched from the inside and left open.

The stolen boots and wallet were found some hours later in the woods behind the house. With them were some half-eaten watermelons and corn husks, suggesting that someone had recently made camp there. A trail of two sets of footprints, one barefoot, was found leading to Walker's woodpile.

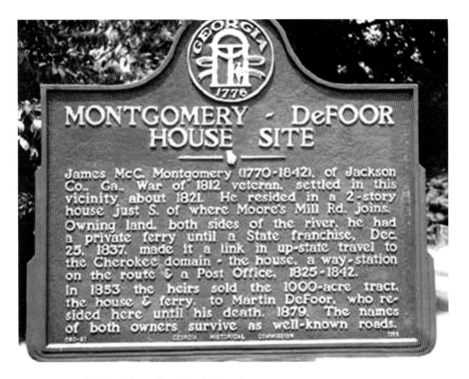

Montgomery-DeFoor House Site historical marker.

On July 27, 1897, the *New York Times* ran an article stating that two tramps had shown up at the DeFoors' house on the Thursday prior to the murder and had asked for lodging and a meal. Because he had been uncomfortable with the men's rough appearance, DeFoor had refused. They were last seen making their way to the river. On the evening prior to the murder, a different tramp had called at the DeFoors' house and asked for directions to Marietta.

The elderly couple was friendly and popular within the community and had no enemies. This made the locals both disturbed by and suspicious of the vagabonds who had recently visited the DeFoor homestead. However, the sheriff and deputies could not understand why the murderers had not taken the money.

Local sheriff William A. Wilson wasted no time getting to work on the case. He immediately sent telegrams to Marietta to prevent any suspicious people traveling that way, and a search party was sent out on horseback and on foot in various directions surrounding Iceville. According to a report published in the *Georgia News* on August 1, 1897,

"A negro tramp by the name of Asa Morgan was caught Monday and confessed to being one of the murderers. He says that there is another negro and a white man connected with the murders."

In a letter written to her daughter, Margaret Walker Cash, on October 12, 1879, Louisa DeFoor Walker stated, "Maggie, they committed Asy Dunn to trial. I don't know when his trial will come off. Some think he was all that did that awful deed. If there were others I hope he will tell on them. Oh tis an awful crime to go unpunished. I hope the right ones will be brought to justice."

Despite having made a number of arrests, Sherriff William A. Wilson and his deputies were unable to solve the crime, as the clues all led to dead ends. No one was ever tried for the crime, and the identity of the true perpetrators remains a mystery to this day. Two months after the murder, son-in-law Thomas Moore tore down the house and used the remnants to make a barn on a lot across the street. The DeFoors' property amounted to $4,500 in real estate, and $1,500 in cash was divided equally among the four heirs.

Martin and Susan DeFoor are buried in a single grave in the Montgomery family cemetery not far from where their home used to stand. The inscription on their grave reads:

SACRED
To the Memory of
MARTIN DEFOOR
Born Sept. 17th 1805
Died July 25th 1879
Aged 73 years, 10 Mons.
And 8 days

SACRED
To the Memory of
SUSAN DEFOOR
Born Dec. 2nd 1798
Died July 25th, 1879
Aged 81 years, 5 Mons.
And 23 Days

Lovely and pleasant
in their lives and in

their death they
were not divided

Father, Mother here
are sleeping
'Neath fair Georgia
lovely sky
While their own loved
Chattahoochee
Near their grave is
gliding by

In a boat veiled in
deep silence
They have crossed
death's darksome tide
And now freed from
every sorrow
Saints forever they abide

The old Montgomery settlement was located on the west side of what is now named Chattahoochee Avenue and a little way north of Moore's Mill Road. A few years after the murder, a bridge was erected across the river and the ferry was never used again. Today, the site of the old ferry is marked by a railway expansion bridge.

THE DISAPPEARING BRIDE

Mary Shotwell Little

In 1965, Atlanta was just beginning to enjoy the excitement of a new level of expansion. With less than a third of today's population, the city was just building the Atlanta–Fulton County Stadium, and the Atlanta Falcons became a new National Football League expansion team. In just three years, the opening of Underground Atlanta would highlight the downtown area on the entertainment map.

Mary Shotwell Little disappeared from Atlanta on October 14, 1965. She has never been found, despite the efforts of a team of experienced investigators. The investigators were not even able to hone in on any strong suspects. No one has ever learned the truth about what led to her mysterious disappearance. This case is probably the most bizarre that the city has ever known. It shook the community and devastated those close to Mary.

Like many of her peers, Mary had moved to Atlanta from a surrounding state, in her case Charlotte, North Carolina, where she had grown up in a middle-class family. After studying secretarial science at the Women's College of the University of North Carolina, Mary had hoped to move to New York. Her parents had dissuaded her and encouraged her to move to Atlanta, where, ironically, they thought she would be at less risk of harm.

When she disappeared, Mary Shotwell Little was twenty-five years old and had been married for only six weeks to bank examiner Roy Little. On the day of his wife's disappearance, Roy was in LaGrange

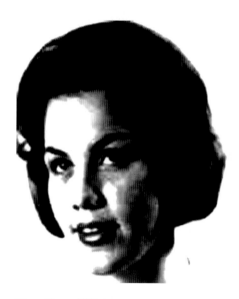

Mary Shotwell Little.

completing auditor training for the state Banking Department. Mary was planning a party at their apartment on Line Circle in Decatur to welcome him home the following day. After work on October 14, Mary went grocery shopping and then met co-worker Isla Stack for dinner at the Piccadilly Cafeteria in the Lenox Square Shopping Center in Buckhead. According to her friend, she was in high spirits during dinner and spoke about how happy she was being married to Roy. Mary left the restaurant about 8:00 p.m. and walked back to her car alone. She was never seen or heard from again.

Mary Shotwell Little was five feet, six inches tall and weighed 120 pounds. She had light brown hair and green-hazel eyes. At the time of her disappearance, she was wearing a long-sleeved, olive green cotton dress printed with white flowers. She also wore a white London Fog raincoat, flat shoes, a platinum wedding ring, a solitaire engagement ring, a Women's College of the University of North Carolina class ring and a scarab bracelet. She was carrying a John Romain purse.

Mary worked at the C&S Bank (now known as Nations Bank) in Atlanta. When she did not show up at work the next day and did not call in sick, her boss became concerned, as this was completely out of character for his diligent employee. Her boss, Eugene M. Rackley, called Mary's home and spoke to her landlady, who informed him that Mary had not collected her morning newspaper. He then spoke to Isla Stack, the friend with whom she had dined the night before. Isla remembered that Mary's car, a new metallic pearl-gray Mercury Comet, had been parked in a parking lot during the previous evening's dinner. Security searched for the car but notified Rackley that it could not be found. He was so frustrated that he drove to Lenox Square about noon to conduct his own search. Within only a few minutes of driving through the crowded

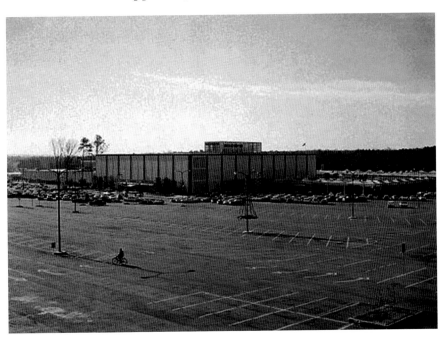

Lennox Square Mall, 1965.

parking lot, he found Mary's car in the yellow section of the lot and notified the police. No one remembered seeing Mary's Comet in the parking lot overnight or at the start of business the next morning. It was later discovered that the license plate on Mary's car was not the legally tagged plate that it had originally carried. Instead, it now had plates recently stolen from a North Carolina vehicle, which may explain why the security guards initially failed to recognize the car in the parking lot. Meanwhile, Mary's husband, Roy, had been notified of her disappearance and was making his way home.

MYSTERIOUS CLUES

There was a distinct layer of red dust on the car, indicating that it had been driven on a dirt road. Mary's four bags of groceries were still inside, along with a packet of Mary's Kent cigarettes and a bottle of Coke. More disturbingly, also inside the vehicle, neatly folded on the

Mary Shotwell Little's car.

console, were a slip, panties and girdle. A bra and one stocking lay on the floor of the car. The stocking appeared to have been slashed with a knife. The underwear was all identified as belonging to Mary and appeared to have been recently worn. Mary's dress, coat, purse and jewelry, as well as the car keys, were missing and have never been located.

The car also revealed more disturbing, though equally mysterious, clues. There were specks of blood on the underwear. Blood was also smeared on the steering wheel, the driver's-side door, around the handle and inside the passenger-side window. There was also a small amount of dried blood on the passenger seat, at the height of the headrest. It contained traces of grass clippings. The amount of blood was relatively small, according to experts, no more than would have been caused by a nosebleed, but testing showed that it was most likely Mary's.

Investigators soon learned that Mary's gasoline credit card had been used in North Carolina the day following her disappearance. The first time was in the small hours of October 15, in her hometown of Charlotte, at an Esso station. The second time was about twelve hours later at an Esso station in Raleigh. The credit card slips were signed "Mrs. Roy H. Little," Mary's usual signature, and the handwriting was authenticated.

When questioned, attendants at both stations remembered seeing a young woman accompanied by one or two middle-aged men who seemed to be giving her instructions. They also reported that the woman seemed to have a minor head injury and had bloodstains on her hands and legs. One of the attendants also said that the woman seemed to be trying to hide her face and made no attempt to ask for help.

By the evening of October 15, a recent photo of the young brunette was on every TV screen and newspaper. Search parties combed the Buckhead and Atlanta areas. Posters offering rewards of $1,000 and $3,000 were posted all over the state.

MANY UNANSWERED QUESTIONS

Police began to fear that Mary had been abducted by a psychopath, and chances of finding her alive seemed to lessen by the minute. Yet how could a young woman have been overpowered and forced to undress in a parking lot at 8:00 p.m. without drawing attention? Because this seemed so unlikely, detectives figured that Mary had been abducted in her car and then forced to drive to another location. However, this theory led to an equally bizarre conclusion: that the

kidnapper had the audacity to bring the car back to its original location in broad daylight.

Investigators were also puzzled by the time lapse between the two expenditures on the credit card, given the fact that, by car, Raleigh is only two or three hours from Charlotte. They theorized that perhaps whoever had abducted Mary was trying to leave a false trail to impede any investigation. When the police compared Mary's odometer and her husband's mileage logs, the car had been driven only forty-one miles that were unaccounted for.

After details of the credit card slips came out in the news, Roy Little received a ransom demand for $20,000 for Mary's safe return. The anonymous caller told Little to go to an overpass in the Pigsah National Forest in North Carolina. He was told he would find further instructions posted on a sign there. An FBI agent traveled there in Roy's place, but all he found was a blank piece of paper posted on the sign. The anonymous caller did not contact Little again and was never identified.

Because of the small amount of blood and the misleading evidence, some police officers believed that Mary may have staged her own disappearance. Yet by all accounts she was a diligent and hardworking young woman who was happy in her new marriage. Her friends and family did not believe that she would intentionally flee without a trace.

POSSIBLE THREATS

During the investigation, it came to light that Mary may not, after all, have been the carefree, happy young newlywed whom people supposed her to be. One of her old high school friends told the authorities that Mary had recently spoken of her fear of being home alone and, strangely, of being alone in her car.

Several of Mary's co-workers also remembered that she had received a number of phone calls at work that seemed to leave her shaken and distressed. Though she never discussed the calls with any of her colleagues, one or two of them had overheard enough to make them concerned. On one occasion, it was reported that she told the caller, "I'm a married woman now." She then added, "You can come over to my house any time you like, but I can't come over there."

Detectives also discovered that shortly before her disappearance, Mary had received a delivery of red roses from an anonymous admirer. Although the police traced the flowers to a florist not far from Mary's home, they were unable to obtain any information about the person who ordered them.

For a short time, there was some speculation that Mary's disappearance may have been connected to an ongoing scandal at the bank where she worked. The bank had hired a former FBI agent to investigate rumors of lesbian sexual harassment and claims of prostitution on the bank's property. It is known that Mary was aware of the scandal, but it is now considered unlikely that it had anything to do with her disappearance.

ROY LITTLE AS SUSPECT

Roy and Mary had met the year before at a Georgia Tech–Alabama football game. After dating for almost a year, the two married and moved into the Belvedere Apartments in south Decatur. Police, of course, investigated Roy for possible involvement in his wife's disappearance. They were surprised to find that many of Mary's friends and former roommates disliked the man so much that they had refused to attend the wedding. Investigators became suspicious when Roy seemed to show little concern about Mary's disappearance and also because he refused to take a lie detector test on a number of occasions. Despite the cold feelings against Roy, police could not pin anything on him because he had an airtight alibi. There were also no signs of disharmony in their marriage, and Roy had nothing to gain from his wife's death.

THE INVESTIGATION CONTINUES

After two weeks with little result, the investigation was taken over by Atlanta homicide detective W.K. "Jack" Perry. A native of Atlanta, Perry was renowned for his excellent success rate for solving homicide cases. With his dogged persistence, Perry had proved himself more

than capable of reopening cold cases and honing in on the guilty culprit. However, despite his experience and a trip to North Carolina to the gas stations visited by Mary and her abductors, Perry could find no leads. Months and then years passed. Every now and then, the police would receive a lead that would turn out to be a hoax. FBI agent Jim Ponder became involved in the case in 1965. One of the last investigators of the case still living, Ponder thought he may have a new break after he'd been on the case for two years.

A Link to Mary Shotwell or a Deadly Coincidence?

In May 1967, a woman named Diane Shields was found murdered in an Atlanta suburb. Like Mary Shotwell Little, she had once worked at the C&S Bank and had actually taken over Mary's desk after Mary disappeared. Diane was last seen leaving work in her blue and white Chevrolet Impala on May 19, 1967. She never arrived home. The car was found about 2:30 a.m. by police officers on a routine patrol. It was parked near a laundromat on Sylan Road in Atlanta. A nine-foot trail of blood led to the car. The officers found Diane Shields's body inside the trunk. She was fully clothed and had not been sexually assaulted; she was also still wearing her diamond engagement ring. She had been strangled to death, though police also reported that she had received a blow to the back of the head. It is reported that, like Mary Shotwell Little, Diane Shields also received some flowers from a mysterious stranger while employed at the bank. Eventually, however, police traced the sender of the flowers and cleared him of the murder. According to a report in the Ohio *Times Recorder* on May 21, 1967, Diane Shields at one time had the same roommate as Mary Shotwell Little. Diane lived with Sandra Green for several months until moving in with her sister, who had relocated to Atlanta. No connection was found between the murder of Diane Shields and the disappearance of Mary Shotwell Little. Though police concluded that the two cases were unrelated, like the disappearance of the young bride, the Shields murder has never been solved.

Mary Shotwell Little's father, Nathan, died in 1979. Her mother, Margaret, still lives and has never stopped searching for her beloved

daughter. Former FBI agent Jim Ponder, a firm friend of the Shotwell family, is still perplexed by this case, the only one he has never solved. Although it is still possible that someone may come forward with new information, the local police files on the case have disappeared as mysteriously as Mary herself. Because there is no surviving physical evidence, a DNA conviction is virtually impossible.

SERIAL KILLING

The Atlanta Youth Murders

During the 1970s, Atlanta went through a number of transitions that brought the city to a new level of maturity. At the outset of the decade, the city had only three skyscrapers, a one-terminal airport with no international flights and a public transport system that provided only buses. At the time of the 1970 census, there were more African American residents than white people, and it was only a matter of time before the city elected its first black mayor. Maynard Jackson was elected in 1973, served eight years and returned for a third term in 1990. In his role of mayor, one of his main priorities was to secure more municipal contracts for minority businesses. He was also responsible for the building of the new terminal at Hartsfield Atlanta International Airport, which was renamed Hartsfield-Jackson Atlanta International Airport in his honor in 2003. Jackson now rests in Atlanta's historic Oakland Cemetery.

In 1979, MARTA launched the initial stage of its rapid transit system after more than two decades of planning. That same year saw the beginning of a series of murders that changed the lives of many Atlanta families forever. The wave of killings began with the disappearance of fourteen-year-old Edward Hope Smith. On July 21, 1979, Edward left his home in the Cape Street housing project in south Atlanta to go and meet friends at a local skating rink. After spending the evening there with his girlfriend, he left about midnight. He was never seen again. A few days later, Edward's friend, fourteen-year-old

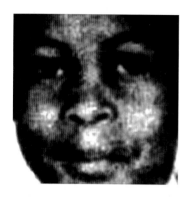

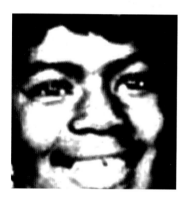

Top: Victim Yusef Bell.

Middle: Victim Angel Lenair.

Bottom: Victim LaTonya Wilson.

Alfred Evans, went to see a movie at a cinema in downtown Atlanta. He never made it to the movie. The bodies of both boys were found on July 28 in a small patch of woods close to Niskey Lake Road. Edward had been shot with a .22-caliber pistol and Alfred had been strangled. At the outset, police thought that the killings were related to local drug dealers, yet this was never proven.

In early September of the same year, Milton Harvey borrowed a bicycle from a friend and disappeared while taking a check to the bank for his mother. The bicycle was found a week later in a remote Atlanta location. His body was found in a garbage dump in East Point a further two weeks later. The cause of death remains unknown due to the extreme decomposition of his body. Yusef Bell became the next victim. The nine-year-old boy was sent to the store to get some snuff for a neighbor. He was never to return home. Witnesses described seeing Yusef get into a blue car just before his disappearance, but police discredited the information. His body was found on November 8 at a deserted elementary school. He had been strangled.

At the time, the police did not believe that the four murders were connected. Yusef's father was treated as a suspect in the boy's death for more than a year. The child's outspoken mother, Camille, disagreed that there

was no connection between the four boys' disappearances, and she was not alone. She formed STOP, the Committee to Stop Children's Murders, along with Reverend Earl Carroll and the mothers of other victims Willie Mae Mathis and Venus Taylor. Its purpose was to urge the authorities and black politicians to stop dragging their feet and take further action to prevent the murder of more children. Mayor Maynard Jackson promised an exhaustive investigation. Thanks to STOP, the cases finally began to get media attention.

The killings stopped until early 1980, when twelve-year-old Angel Lenair went missing on March 4 after leaving her home in north Atlanta. She was found six days later bound to a tree. The first female victim, Angel had been sexually assaulted and strangled with a piece of electrical cord. A pair of underwear that did not belong to her was stuffed into her throat.

On March 11, Jeffrey Lamar Mathis disappeared while going to a local store to get his mother Millie May some cigarettes. Authorities believed that he may still be alive until the remains of his body were found eleven months later. Because of the decomposition of Jeffrey's body, the coroner was unable to state a cause of death. Police originally suspected that six juvenile gang members were involved in this murder. Several witnesses described having seen Jeffrey in a blue car, possibly a Buick, that was being driven by a white man. The police did not pursue this line of enquiry.

Fourteen-year-old Eric Middlebrooks left home after receiving a phone call on May 11. He took his tools with him and told his mother that he was going to repair his bike. He was not seen alive again. His body was found the next day, his bike nearby. His cause of death was from head injuries inflicted with a blunt object.

As the summer temperatures began to rise, so did terror in the heart of many Atlanta parents. On June 9, Christopher Richardson left home to go to a local swimming pool in Decatur. He never arrived. Less than two weeks later, six-year-old Latonya Wilson was abducted from her bedroom on the night before her birthday. Authorities suspected that a family member may be involved due to the fact that the child was sleeping in a room with other siblings who were undisturbed. Latonya Wilson's remains were not discovered until October 18, 1980, by which time her body was so decomposed that experts were unable to determine her cause of death. The girl's body was found by a civilian search team, which added further strength to the criticism that the

police were not making sufficient efforts to protect Atlanta's children and find the killer.

The day after Latonya vanished, the distraught parents of ten-year-old Aaron Wyche reported him missing. His body was found on June 24 under a highway bridge. His neck had been broken. Although authorities originally thought that Aaron's death was an accident, his name was added to the growing list of dead and missing black children.

Nine-year-old Anthony Barnard Carter was added to the list on July 6, after disappearing while playing near his home. His body was found the following day less than a mile from his home, with multiple stab wounds. The police initially arrested his mother but eventually released her; however, they continued to follow and question her for months, to the extent that she had to move away from Atlanta.

The next victim was Earl Terrell. A lifeguard kicked him out of a local public swimming pool for misbehaving on July 30. He mysteriously disappeared. Earl's aunt reportedly received a call from a man who claimed to have the boy in Alabama. The caller demanded a $200 ransom for his release. Because it was believed that Earl may have been abducted and transported across state lines, it finally meant that the FBI had jurisdiction to join the case, much to Mayor Jackson's relief. Despite the FBI's additional task force, Earl was not found and his remains were not discovered until January 9, 1981. Because of their advanced state of decomposition, they could reveal no clues to the cause of death.

Thirteen-year-old Clifford Jones was visiting his grandmother in Atlanta when he disappeared from the street outside her home on August 20. He was found strangled in a dumpster in October of the same year. He was wearing shorts and a T-shirt that did not belong to him. Several witnesses claimed to have seen Clifford enter a back room of a local laundromat with the manager. One of them claimed that he saw the manager beat the boy, strangle him and then carry his body outside to the garbage dumpster. According to the FBI files, the witness failed two polygraph tests. Though it was known that Clifford had been at the laundromat and his time of death indicated that the laundromat manager may have been with him at the time, the authorities didn't arrest the man. Instead, they claimed that the young witness's statement was too unreliable because he was "retarded." Several other witnesses claimed to have seen the same man dumping

Victim Darron Glass.

a large, plastic-wrapped object into the dumpster behind the laundromat on the night before Clifford's body was found. Police did not pursue this information; they then added Clifford to the list of other victims.

Another name was added to the list on September 14, 1980, when eleven-year-old Darron Glass disappeared near his home. His foster mother reported to the police that she had received an emergency phone call from a boy claiming to be Darron, but when she reached the phone, the line was dead. Because Darron had a history of running away from his foster home, police did not follow up on the report. Darron was never found.

Charles Stephens was reported missing on October 9, and was found the next day. He had been smothered by an unknown object. A police officer threw a blanket over the boy's body, which contaminated the crime scene by mixing fibers from the blanket with those already on the scene, destroying any potential evidence.

The same month, Mayor Maynard Jackson issued a curfew throughout the city, fearing that the murderer would kill again over Halloween while trick-or-treaters roamed the neighborhoods. Despite the curfew and increased neighborhood police patrols, the authorities failed to prevent another murder. The month of November dawned with the disappearance of Aaron Jackson. He was found beneath a bridge near the South River, not far from where Aaron Wyche's body had been found. Like many of the other victims, he had been asphyxiated.

On November 10, Aaron Jackson was joined by his friend Patrick Rogers, age fifteen. Patrick's remains were not discovered until February of the following year. His skull had been pulverized by heavy blows to the head. Police discovered that Patrick was connected to at least seventeen other murder victims, some of whom were on the list.

A Pattern of Confusion

The investigative task force was struggling to make sense of the connection between the victims on the list. What made it difficult was the fact that the murders seemed to display so many variables, such as cause of death, modus operandi and killer signatures. Comparing some of the individual cases, such as the abduction of LaTonya Wilson and the stabbing of Clifford Jones, suggests two completely different perpetrators. However, as more victims were added to the list, a pattern began to emerge that did seem to signify that some of the murders were connected. All of the victims were black, mostly boys and all of small build and similar physical characteristics. Though a number of the victims' cause of death was unknown and two had been shot, most of them had been asphyxiated, and all of the bodies had been left at locations where they would be easily found. Several of the victims, including Lubie Geter and Earl Terrell, had connections with local male pedophiles, and further evidence revealed that a number of them had had homosexual relationships.

Despite these connections, due to the constantly changing parameters of the victims list, it began to seem as though the police were befuddling themselves. Police files contained inconsistencies and errors, and some reports remain missing to this day. According to Chet Dettlinger—ex–police officer, public safety commissioner and consultant for the U.S. Justice Department—many more victims should have made the list. After offering his services to the Atlanta Police and being refused, Dettlinger initiated a voluntary investigation into the Atlanta murders. Working alongside STOP to try and prevent any further murders, his team included private investigators Mile Edwards and Bill Taylor as well as ex-crime analyst Dick Arena, who was an expert at examining patterns and trends in this type of crime. Dettlinger and his team diligently mapped out the killings and went door to door through the neighborhoods to track down leads to the murders. He discovered that all of the victims had a connection to Atlanta's Memorial Drive and eleven other streets in the near vicinity, directed in an easterly direction. The team also discovered that not only was there a definite pattern between the victims, but there were also at least sixty other victims who had not made the list. Dettlinger pointed out a distinct social and geographic pattern between the victims, to the degree that he was able to estimate with

accuracy where victims would vanish and where their bodies would be found. To the frustration of his team and STOP, the Atlanta Police and the FBI task force were still reluctant to make any connection between the cases, let alone more than sixty other cases that shared the same pattern. At one point they even suspected that Dettlinger had something to do with the murders. The authorities released him when they finally realized that it was their own mismanagement of information that was letting them down. When the FBI realized that the ex–police officer had collected more information than their task force, they invited him to join their team, and he helped them connect the cases.

A New Year, an Old Case

The new year found the community chilled by growing fear and despair for their children and a police force that seemed powerless to stop the tragic slayings. Two days later, fourteen-year-old Lubie Geter became the seventeenth victim to be added to the list. Lubie was abducted from close to his home and his body was found, strangled, on February 5.

Lubie Geter's friend, fifteen-year-old Terry Pue, vanished from a burger bar on Memorial Drive and was found the next day near Interstate 20 on Sigman Road, after an anonymous caller told authorities where to find his body. He had been strangled by a piece of cord. This time, it seemed that detectives had a break in the case, as they

Victim Lubie Geter.

were able to lift fingerprints from Terry's body. Unfortunately, they were unable to match the prints with any on file. The same caller had also informed the police that there were other remains nearby. Several years later, the other remains were uncovered, though never identified and never added to the list. Some believe that they may have been the remains of the missing Darron Glass.

On February 6, Patrick Balthazar, age twelve, disappeared. After his

77

disappearance, his teacher said that she had received a call from a boy she believed to be Patrick. She said that the caller did not speak but cried into the phone before hanging up. His body was found the following week by a groundskeeper in an office park. He had been strangled with a rope or cord. The skeletal remains of Jeffery Mathis were found close by.

Thirteen-year-old Curtis Walker became the next victim. He vanished on February 19, and his body was found the same day in the South River. His cause of death was listed as probable asphyxiation with a rope or cord.

On March 2, sixteen-year-old Joseph Bell disappeared. Two days later, a friend and co-worker at Cap'n Peg's restaurant told police that he'd received a telephone call from Joseph, who had claimed he was "almost dead" and begged for help. The same week, Joseph's mother received a call from an anonymous woman who claimed she had Joseph. The same woman made a number of calls to the family, and on another occasion talked to the other children. Though Mrs. Bell called the Atlanta task force, no one contacted her. Before the FBI could come to her assistance, Joseph was found on April 19 in the South River. Medical experts said he had probably been asphyxiated.

Joseph's friend Timothy Hill disappeared later that same month. Timothy was last seen by a next-door neighbor on March 12. He was found on March 30 in the Chattahoochee River. His cause of death was asphyxia.

RESIDENTS PROTEST

By now, there had been more than twenty victims added to the list, and the public opinion was that the "Atlanta children's murder" case was getting out of control. Residents of housing project Techwood Homes united in protest on the streets, claiming that the Atlanta Police were not doing all they could to protect Atlanta's children. The same residents formed a vigilante group, which they called the "bat patrol." Armed with baseball bats, they aimed to prevent any further murders. The continued tragedies highlighted the tension and feeling of betrayal of the black community by the Atlanta Police. Camille Bell summed up the feeling of vulnerability when she told *Newsweek*, "There are actually people who can walk into your

neighborhood, in broad daylight, steal your children, murder them and throw them back in your face." Eleven members of New York's unarmed citizen crime patrol team, the Guardian Angels, joined the Atlanta group in its day and night search for missing children and to protect those still alive. Community activist Chimurenga Jenga was convinced that the murders were racially motivated and formed an armed vigilante group to patrol the Techwood estate.

In March 1981, the *New York Times* reported that Mayor Jackson's response to the residents' concern was to urge them to "lower their voices" about the possibility that the murders were racially motivated. Jackson was still confident that the Atlanta task force, which now numbered forty investigators, would crack the case. Members of the task force were working from a converted building on West Peachtree Street. They had a sophisticated computer system at their fingertips and numerous volunteers manning the telephone tip lines. They even brought in renowned psychic Dorothy Allison, who had previously participated in other high-profile cases. To offset the cost of the $230,000 investigation, the Reagan administration presented Atlanta with $1.5 million in federal funds, and both black and white citizens pitched in with a $100,000 reward for any information leading to an arrest. Despite this and the use of air patrols and expert criminal profilers, neither the task force nor the volunteers was able to prevent another murder.

On March 20, 1981, twenty-one-year-old Eddie Duncan disappeared. Eddie became the first adult to make the list of "Atlanta child murders." His body was found on April 8; he had also been dumped in the Chattahoochee River. Prior to Eddie's murder, older victims had been kept off the list because they did not fit the age group parameters, despite other connections. Perhaps Eddie was added due to the fact that he had a number of physical and mental disabilities. Like many of the other victims, his cause of death was thought to be asphyxia.

Twenty-year-old Larry Rogers was the next victim to be added to the list, which by now included twenty-two deaths and three disappearances. After being missing for two weeks, Larry's body was discovered in an abandoned apartment. Despite his age, he was added to the list case because he reportedly had the mental age of a seven-year-old and his peer group was composed of young children. He, too, had been asphyxiated by strangulation.

Once again, the parameters of the list were beginning to seem arbitrary, and residents criticized it for being incomplete, using the murder of Faye Yearby, which took place in January 1981, to make their point. Like list victim Angel Lenair, twenty-two-year-old Faye had been bound to a tree with her hands behind her back and viciously stabbed to death, like four other victims on the list. Despite these similarities, police did not add Faye to the list on the grounds that she was female (as were two other victims) and she was too old (two other victims were also in their twenties).

The Atlanta community was further outraged later that month when FBI spokesman agent Michael Twibell, speaking at a civic club meeting in Macon, Georgia, stated that the Atlanta murders did not signify a "great crime wave sweeping Atlanta," but that the parents may have killed their children because they were a burden.

Community Crisis Continues

The black community continued to deal with the crisis in a number of ways, including safety education programs, prayer vigils and organized searches for the missing children, but, tragically, the slayings continued through April. It did little to help ease the pain of friends and family of Jimmy Payne. Jimmy was a twenty-one-year-old former convict who was reported missing in Atlanta on April 22. He was last seen alive by his girlfriend on the morning of his disappearance when he walked to her bus stop for work. When he did not meet her at the bus stop as usual after work, she became concerned and later reported him missing. His body was discovered six days later, and when his cause of death was pronounced as asphyxiation, he was added to the list of victims. Also in April, the body of Michael McIntosh, a friend of victim Joseph Bell and Nathaniel Carter, was recovered from the Chattahoochee River. He had been missing since March 25. His cause of death was also reported as asphyxia. The same month, the body of John Porter, another former convict, was recovered in a parking lot in Atlanta. He had been savagely stabbed to death. Porter was not added to the victim list until later, when the Wayne Williams trial was underway and Williams was linked to John Porter through fiber analysis.

The last two victims to make the list were seventeen-year-old William Barrett and twenty-seven-year-old Nathaniel Cater. William Barrett disappeared in May 1981 en route to pay a bill for his mother. His body was found the next day not far from his home. He had been strangled to death and then stabbed multiple times. Police reports connected William with a white male who had been previously convicted of pedophilia. The unnamed male had allegedly also been connected by witnesses to victim Lubie Geter.

The Police Make an Arrest

Because a number of bodies had now been recovered from the Chattahoochee River, Atlanta Police were staking out the area on a nightly basis. In the early hours of May 22, 1981, Atlanta police officer Bob Campbell was on surveillance beneath the James Jackson Parkway Bridge when he heard a loud splash in the water not far from his position. He described the splash as being louder than any caused by a diving animal. He also reported seeing a series of large ripples after the splash. At the time, a car was parked on the bridge with its headlights shining over the area where Campbell had seen the ripples. Officer Freddie Jacobs was stationed on the southern part of the bridge. At this time, Jacobs saw a white Chevy station wagon approaching from the southern end of the bridge. He watched the car drive over the bridge into Fulton County and then turn around and recross the bridge. Campbell radioed FBI agent Greg Gilliland, who pulled the car over about a half mile from the bridge. The vehicle was being driven by Wayne Bertram Williams, a twenty-three-year-old African American from Atlanta.

The son of two schoolteachers, Williams was born and raised in Atlanta's Dixie Hills area, where he still lived with his parents. He had dropped out of Georgia State University and was following his aspirations to become a music promoter and freelance photographer. He also ran an amateur radio station from his home. He was known throughout his neighborhood for scouting local musicians and recording demo tapes for them. He had one previous arrest for impersonating a police officer in 1976, but he was not convicted.

When questioned about his presence on the bridge, Williams said that he was looking for the address of a female singer he wanted to

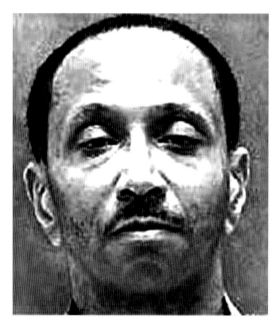

Wayne Williams.

audition. Two days later, the naked body of Nathaniel Cater was recovered from the river, downstream from where the police officers had heard the infamous splash. Nathaniel Cater, the final victim to be added to the list, had lived in the same apartment building as LaTonya Wilson. Despite the fact that several witnesses claimed to have seen Cater after May 22, police arrested Williams for his murder.

WAYNE WILLIAMS'S TRIAL

The trial began on December 28, 1981. The jury was composed of nine women and three men; four jurors were white, eight were black. Williams's defense team was made up of Atlanta attorney Mary Welcome and Mississippi lawyer Alvin Binder. The prosecution team included district attorney Lewis Slaton and lawyer Jack Mallard. The prosecution presented Williams as a homosexual bigot and a mission-oriented killer who was aiming to wipe out the future generation of African American youth. The initial evidence in the case was circumstantial and was based on the location of Williams's car, as witnessed by Police Officer Jacobs. The evidence that sealed

Williams's fate was the forensically tested fibers that were found on some of the victims' bodies. These were matched to fibers found in Williams's home and car.

Though fiber testing was not a particularly new process at the time, the way that the evidence was used in the case was unusual and set a precedent for future cases. To the layperson, individual fibers may seem very simple and lacking in information. A forensic scientist, however, can extract a wealth of information from just a few single fibers, and this information can completely change the track of a criminal case. Kadish, Davis and Kadish explain that scientific tools such as spectral data processors and monochromators can be employed to extract information that is unavailable to the naked eye. Such information can reveal the chemical components of the fiber's material, individual characteristics such as markings upon the fiber's surface, information about the dying and weaving process and even different finishing chemicals used on the fibers. These details, in combination, can tell an investigator where, when and how the fiber was made and what type of material it originated from.

The fibers found on the Atlanta victims' bodies were an uncommon type that were eventually identified as a yarn used by a Georgia carpet company called West Point Pepperell, which used it in its Luxaire line. The fibers on Nathaniel Cater's body were Luxaire English Olive, which made them an exact match to the carpet in Wayne Williams's home. According to West Point Pepperell's sales records, only one in every eight thousand Atlanta homes contained this particular carpet. In Williams's defense, Binder told the jury that a number of policemen had handled the bodies and so the evidence had been contaminated. He suggested that the fibers could have come from the officers themselves, but faced with the rarity of the carpet, the jury was not convinced.

The prosecution submitted that Williams had hoisted Nathaniel Cater, who weighed 146 pounds, and Jimmy Ray Payne, who weighed 138 pounds, up and over the four-foot wall on the James Jackson Parkway Bridge and thrown the bodies into the Chattahoochee River. Binder counteracted this by stating that Williams was not physically fit enough to single-handedly lift the bodies over the wall.

There was also some controversy related to the murder charge of Jimmy Payne. This stemmed from the fact that Dr. Saleh Zaki, associate Fulton County medical examiner, had initially declared that

his cause of death was "undetermined," which means that it could not be proven that Payne had in fact been murdered. However, the day following Williams's arrest, Zaki conveniently changed the cause of death to read "homicide." Under cross-examination, Zaki stated that Jimmy Payne had died of asphyxia, and though he might have accidentally drowned, bruises on his body and a lack of water in his lungs made it improbable.

Several witnesses for the prosecution testified that Williams had homosexual relationships, including one who claimed to have seen Williams holding hands with Nathaniel Cater on the night of May 21, just a short time before Williams was detained on the bridge. Another fifteen-year-old male witness told the court that Williams had once paid him two dollars to allow him to fondle the boy's genitals.

Doubt might have been cast upon Williams's guilt by the fact that thirty-nine-year-old Jimmy Anthony, a friend of Nathaniel Cater's, claimed to have seen him on May 23, the day after Williams had supposedly thrown Cater's body into the Chattahoochee River. However, Anthony never got to testify. The defense did try to counterbalance the prosecution's negative presentation of its client's sexuality by introducing a female witness who admitted to having "regular" sex with Williams, but the prosecution ramped up its attack when Jack Mallard presented a pattern that connected the murders of Jimmy Payne and Nathaniel Cater to ten other murders on the victim list. The other ten victims were:

- Lubie Geter
- Terry Pue
- Alfred Evans
- Joseph Bell
- Larry Rogers
- Patrick Balthazar
- John Porter
- Charles Stephens
- Eric Middlebrooks
- William Barrett

The judge permitted evidence in the ten other cases to be presented in the two murders with which Williams was charged. The prosecution stated that fibers found on the additional victims' bodies

matched the trunk lining of the 1979 Ford owned by the Williams family. The body of Charles Stephens reportedly yielded fibers from a 1970 Chevrolet also owned by the Williams family.

According to the defense, Williams could not have had any access to the cars at the time when these victims were killed because Williams's father had taken the Ford to a garage to be repaired at 9:00 a.m. on July 30, 1980. He collected the car on August 7 and returned it the next day because it still would not start. It is reported that the additional repair costs were so high that Williams refused to pay and never collected the car again. As for the 1970 Chevrolet, the family did not purchase it until October 21, by which time the other victims linked by the fibers had already been murdered.

Despite this, the prosecution had further fiber evidence that was found on several victims' bodies. This was a flammable acetate fiber once used in bedspreads. The fibers exactly matched a bedspread found in the Williamses' house. From this evidence, it was submitted that Williams had murdered the victims in his parents' house, wrapped them in the bedspread and transported the bodies in the trunk of the car.

The jury deliberated, and on February 27, 1982, Wayne Williams was found guilty of the murders of Nathaniel Cater and Jimmy Ray Payne. He was sentenced to a double life imprisonment. After the verdict, the Atlanta Police Department closed twenty-two other cases from the Atlanta child murder list, but Williams was never tried, or convicted, for those crimes. The Atlanta child murders task force officially disbanded on March 1, 1982, after making a public announcement that twenty-three of the murder cases on the list were considered solved with Williams's conviction. The remaining seven cases remained open.

THE KKK CONSPIRACY

Some ten years after the conviction of Wayne Williams, some FBI documentation surfaced. It dated back to the early 1980s, from an investigation into the possibility that a terrorist cell was responsible for the Atlanta killings.

THEORY: That the core killings, of children, in Atlanta, are the work of a small, fanatical, right-wing cell (possibly linked with the KKK, American Nazi Party, Minutemen, or other right-wing organization). Other killings are the work of copycat or cover-up killers, or the victims of random inner city violence."

The report also goes on to say that the pattern suggests that the perpetrators "work at a job where they have Tuesday and Wednesday off (a list of such people would include not only police and fire officials, but also hospital or chain store employees)." The report suggested that the motive behind the killings was to disrupt the black power structure in Atlanta by instilling fear in the community and a lack of faith in government leadership.

GROUP COMPOSITION: It is my estimation that the killer group is made up of four to five, white males, twenty-five to forty years old. These would be males in their top years of physical condition, powerful enough to overcome the resistance of a child without help. As to the size of the group, four men is the most that can fit, with ease, into a single car, and retain freedom of movement. It is also the size of a standard military rifle team, the base unit of any infantry organization. A fifth individual, if involved, would be the team leader and have the closest contact with the major organization.

The document lists three key trends as supporting evidence: there had been a number of right-wing organizations establishing paramilitary units around the country at that time; right-wing terrorist acts were increasing; and the Atlanta killings indicated that the perpetrators were working in a group, which was helping them to avoid attracting attention. The report also suggests that the killers would probably be using cars that would not draw scrutiny, such as plain sedans or small vans, which may be carpeted inside.

The files detail how easily the children might have been persuaded to enter the vehicles. One suggestion was that the perpetrator would offer the victim money in exchange for work. Another was a slightly more complicated ploy. It was suggested that an accomplice would follow the victim and a second perpetrator posing as a law enforcement officer would tell the victim that the person following him is linked to the Atlanta child killings, coercing him into the car for the sake of

his own safety. The author of the report says that at least eight of the murders at that time were indicative of a terrorist cell and that the murder of Angel Lanier was probably a mistake and the killers did not realize she was a girl until she had been lured into a trap; by that time, they had decided to kill her anyway.

Around the time that this report was written, the FBI was investigating key KKK member Charles Sanders, who reportedly confessed to an FBI informant that the Klan was killing children each month until things blew up within the black community. In the transcript of his taped conversation, Sanders also mentions that the Klan was killing black adults in other cities. He also threatened to kill Lubie Geter.

Some critics of the investigation believe that a deliberate blind eye was turned on the KKK involvement to avoid major racial conflict. They also point to reports that law enforcement officials had destroyed the tape-recorded confession in which Sanders revealed to the FBI informant that he had, in fact, killed Lubie Geter and intended to kill more black Atlanta children.

A COLD CASE REOPENED

Louis Graham began his career in law enforcement with the City of Atlanta Police Department in 1965. By 1972, he had risen to the rank of commander of the Atlanta homicide division, the first time an African American police officer had been given such a prominent position in the Atlanta Police force. He was also the first African American to join the service of the Fulton County police force and became the county's first black chief of police in January 1991.

Since Wayne Williams's arrest in 1981, Graham, who was part of the task force that led to the arrest, always expressed misgivings about the arrest, and he has been critical of the fiber evidence used to convict him. In 2005, Graham reopened four of the Atlanta child murder cases: those of Patrick Balthazar, Joseph Bell, Curtis Walker and William Barrett. Graham told CNN, "Quite frankly, I don't think Wayne Williams is responsible for anything. I don't think he did anything. I made up my mind with that twenty years ago, and I still feel that way."

Graham firmly believed that the cases still held too many unanswered questions, to which he hoped to find answers. He was also

convinced that Williams, who has always maintained his innocence, is not guilty of any crime. A former member of Williams's prosecution team, Jack Mallard, questioned whether Graham's reinvestigation of the cases could be objective, given that he was convinced that Williams was innocent from the outset. Mallard remained convinced of Williams's guilt.

Graham resigned from the police force in 2006 after a federal lawsuit was filed accusing him of punishing officers who were trying to form a police union and racial remarks against white officers. During the year that the case was reopened, police found nothing new on the case. In June 2006, police put the investigation on hold.

LATER EVIDENCE

On February 27, 2007, Georgia judge Thelma Wyatt Cummings ordered DNA testing of evidence used in the trial of Wayne Williams. This type of testing was not available when Williams was convicted in 1982, and it was thought that the DNA tests would throw new light on the case. The test was used to compare hairs found on five of the victims' bodies to those on Williams's dog. The prosecution team did not dispute the testing and remained confident that the tests would not show that Williams had been wrongfully convicted.

The tests revealed that the seven hairs found on the victims' bodies were a match to Williams's dog, Sheba. District Attorney Paul Howard said that this presented conclusive evidence that Williams was guilty, despite criticism from the defense, which claimed that the tests were inconclusive. Williams was denied another trial. He continues to maintain his evidence and claims that he was framed by the KKK.

MURDER FOR HIRE

The Killing of Lita McClinton Sullivan

Atlanta residents saw a lot of changes in the 1980s, including the opening of the new Hartsfield airport at the start of the decade. This allowed international flights in and out of the city and made it the world's largest air passenger terminal complex, covering 2.5 million square feet. By December 1984, a fourth parallel runway was completed, and four years later, MARTA's Airport station opened, linking the airport to Atlanta's rapid transit system. Atlanta experienced some of the highest temperatures on record at the beginning of the decade and lowest by the end. The city was still reeling from the aftermath of the tragic Atlanta child murders in 1987 when another brutal murder took place that was to take hold of the community and the media and would not be resolved until the following decade.

Lita McClinton was the daughter of Emory McClinton, a former U.S. Department of Transportation official, and JoAnn McClinton, a Georgia state representative. Lita was an attractive and elegant black woman who had an interest in the fashion industry. She was described by her friends as generous and caring and always fun to be around. In 1975, at the age of twenty-three, Lita was working in an Atlanta fashion boutique. Around the same time, she fell head over heels in love with James Vincent Sullivan, a thirty-three-year-old white, Boston-born businessman. Despite the fact that her parents did not trust Sullivan and believed he had something to hide—a point that

Lita McClinton Sullivan.

was proven when he told Lita of his previous wife and four children on the night before their wedding—Lita allowed Sullivan to lavish her with gifts and attention. After a whirlwind romance, the couple had a small family wedding on December 29, 1976.

As well as Lita's parents' concerns about Sullivan's honesty, they also had genuine concerns about the couple's plans to move to Macon, Georgia, where they were uncertain about what kind of reception a biracial couple would encounter. The newlyweds did move to Macon, and before long the McClintons' fears became a reality. It soon became apparent that a number of Macon residents did not welcome the couple in their community. Before long, Lita and Sullivan experienced a number of racially motivated incidents, including one in which watermelons were scattered all over their front lawn. As if that was not enough pressure on their marriage, Lita began to notice that Sullivan was not the man she had once thought he was. Friends also noticed a different side to James Sullivan. Lita's closest friend, Poppy Marable, told CBS that Sullivan often criticized Lita for spending his money, and on one occasion he became irate with his wife for spending too much money on Girl Scout cookies. That was not all; Lita soon realized that Sullivan was being unfaithful.

In the hope of salvaging their marriage, the couple gave up hours to guidance counseling, but it did not seem to help the situation. Then, in 1983, Sullivan sold Crown Beverage, Inc., a company he had inherited from his uncle, for $5 million. The couple left their home in Macon and moved into Casa Eleda, an oceanfront mansion in Florida, in the hope that they would be more accepted as an interracial couple within the community and hoping that a change of scenery would inject

James Sullivan.

new energy into their marriage. Sadly, that was not to be. Sullivan's cheating got worse, and he seemed less inclined than before to even attempt to hide it from his wife, who on one occasion found another woman's underwear in her bed. Meanwhile, Sullivan was trying to work his way up the Palm Beach social ladder by just about any means he could manage. Sullivan resented his wife for the fact that Florida's social elite were not welcoming him with open arms; friends say that he blamed it on the fact that she was black.

After suffering nine years of abuse and deceit, Lita finally decided that she could take no more. She left Florida, moved back to the town house in Atlanta and filed for divorce on the grounds of adultery and cruelty. Friends say that she had been planning this divorce for some time. She refused to accept Sullivan's offer of a $2,500 monthly alimony payment and demanded half of his $8 million estate. The settlement ruling was due to take place on January 16, 1987, but that morning, an unexpected and tragic event would take place that ensured Lita would never receive any settlement.

Early that morning, Lita heard someone outside her front door. Still in her robe, she opened the door of her Buckhead home to a white man she had never seen before. The stranger handed her a box of long-stemmed roses and then fired three shots from a nine-millimeter pistol. One of the shots struck Lita in the head.

On the morning of the murder, Lita's neighbor, Bob Christenson, admits that he saw a strange man with a box of flowers in her courtyard, near her door. Though Christenson initially began to approach the stranger, he returned to his own house after seeing that the man was

only delivering flowers. Christenson told *CBS News*'s Susan Spencer that he heard the three gunshots, and knowing of Lita's troubled marriage, his first thought was that Sullivan had hired a hit man. By the time Christenson reached Lita's side, the murderer had escaped but Lita was still alive, though unconscious. A dozen long-stemmed red roses lay in a box at her feet. Tragically, Lita died a few hours later in a local hospital.

Alibis and Evidence

On the day of the cold-blooded killing, Lita's husband was hundreds of miles away at their Palm Beach mansion. Despite this, several of Lita's friends and her parents could not shake the feeling that Sullivan had something to do with the murder. The police began their investigation, but there was no murder weapon and little to go on. Then they discovered that although Sullivan's alibi was tight, he had received a collect call to his Florida home just thirty minutes after Lita's murder. The call was made from a rest stop less than forty minutes from Lita's Buckhead residence. Police suspected that Sullivan may have received the call from the hit man letting him know that the deadly deed was done.

Emory and JoAnn McClinton thought that this meant arrest for Sullivan, but this was not to be. The phone call itself was not enough proof to connect him to the murder, so he retained his freedom. While Lita's parents were dealing with the devastating blow of their daughter's murder and the anguish of knowing that her husband was somehow involved, James Sullivan was still living the high life in Florida. Surprisingly, he did not attend his wife's funeral, nor did he send her family any condolences. Completely unconcerned by his wife's murder, only eight months after her death, Sullivan married his girlfriend, socialite Suki Rogers. This finally gave him the position among the Florida elite that he had so relentlessly sought.

Try as they might, authorities could not find any more evidence to prove that Sullivan had hired a hit man to kill his former wife. Five years later, there was still no evidence for murder, and in frustration, Emory and JoAnn McClinton sued Sullivan for wrongful death and won a $4 million judgment. This did little to appease their sense of loss and frustration with the case, particularly when they found

out that they would not see a penny of it. Sullivan had already stashed his millions in an offshore account and was now living it up in Costa Rica.

According to Emanuella Greenberg, reporting for Court TV, Sullivan's life began to take a downturn in 1990. In traffic court for a minor violation, Sullivan got his wife Suki to testify that she had been driving the car, not her husband. Their story failed to convince the judge, and Sullivan was sentenced to a year of house arrest. Not long after, he accrued another year of house arrest for the illegal possession of firearms. Following this, his wife Suki filed for divorce, and when the courtroom battle between the couple was at its most intense, she announced that Sullivan had confessed to her that he had hired someone to murder Lita. Sullivan was indicted in 1992 for violating commerce laws by using a phone for murder for hire. Facing a possible life sentence and the fact that his wife Suki was to testify against him, Sullivan hired a high-profile defense team run by Donald Samuel. Although the prosecutor produced Sullivan's phone records for the day of her murder, he failed to prove who had placed the calls. After three weeks, the judge dismissed the case due to lack of evidence. Again, Sullivan escaped jail, but his reputation among Florida's high society was in ruins. He sold his mansion and moved to a house in Boynton Beach, Florida.

A BREAKTHROUGH IN THE CASE

The case took an astounding turn in 1998, eleven years after the murder, when a lawyer's receptionist from rural Texas told her boss a story that would change the lives of the McClintons and James Sullivan forever. Belinda Trahan explained that back in 1980, she had been living in North Carolina with her then boyfriend, Phillip Anthony Harwood. Harwood, a forty-seven-year-old mover for North American Van Lines, returned home one night after an overnight trip to Palm Beach and recounted a story that she would never be able to forget.

Harwood told Trahan how he had met a wealthy white man who told him that he wanted to have his black wife killed. Used to Harwood's tall tales, Trahan did not believe his story, even when Harwood told

her that it was going to happen on his next run to Georgia. When Harwood returned from his trip, he told Trahan that the hit had not been successful because the woman had not answered her door. Trahan then regretfully admitted that she jokingly told Harwood that if he wanted a woman to answer her door, he should have flowers with him. The next time Harwood returned from Georgia, he told Trahan that the job was done. Still, she was skeptical, but Harwood was determined to convince her.

Some days later, the two drove to a roadside diner. After waiting for a short while, they were approached by a man who scowled at Harwood and demanded to know why he was not alone. Trahan recalled that the man pushed a folded newspaper across the table to Harwood, who accepted it. It wasn't until they were back in the car that Harwood admitted that inside the newspaper was an envelope containing half the payoff for the murder of Lita McClinton Sullivan. When Trahan saw the money, she finally believed that Harwood was telling the truth. Unable to live with a killer, she left him and returned to Texas. Despite her escape from Harwood, Trahan was afraid to turn him in to the authorities because of his constant threats on her life. She remained silent for eleven years, until finally she could no longer live with the secret on her conscience, and she confided in her boss, lawyer Ed Lieck. When she later told her story to authorities, they were so impressed with the details that they agreed not to press charges for withholding if she agreed to testify.

Georgia Bureau of Investigation agent John Lang was in charge of the case, and as soon as he got Trahan to positively identify a picture of Sullivan, he set about building the case. Lang had another major breakthrough at North American Van Lines. When looking through a box of old records, he found a shipping invoice that had both Anthony Harwood's and James Sullivan's signatures on it.

It was time for Lang to pay Anthony Harwood a visit. When the GBI agent showed up at Harwood's home, Harwood almost seemed to have been expecting him, and he was ready to spill the beans. He gave Lang everything he needed to know, without prompting. At that point, the authorities had clear evidence that Sullivan had hired Harwood to kill his wife. The case against Harwood was tight, and he eventually agreed to cut a deal and pleaded to voluntary manslaughter. He got twenty years in exchange for testimony when prosecutors brought Sullivan to trial.

Murder for Hire: The Killing of Lita McClinton Sullivan

Atlanta district attorney Paul Howard issued a warrant for Sullivan's arrest, though his whereabouts at the time were unknown. Howard also told Sullivan's attorneys that he would be going for the death penalty. Sullivan, who had been soaking up the sun in Costa Rica all this time, went on the run again upon hearing of the death penalty charge from his lawyers. This time he headed for Panama, but he didn't settle there for long. There were sightings of him all over the globe, from Ireland to Guatemala. Eventually, he was spotted by a witness in Bangkok who tipped off the FBI. When local authorities found him living in a condo with his fourth wife, he was immediately put under surveillance. In July 2002, after watching him for two months, authorities arrested him. Sullivan was then taken to a Bangkok prison. After spending nineteen months in the crowded Thai jail, he was extradited back to Atlanta, where he faced charges of murder and aggravated assault.

James Sullivan's trial began in February 2006, some nineteen years after the cold-blooded murder of his wife Lita. The main witnesses for the prosecution were Belinda Trahan and Anthony Harwood. Lita's neighbor and friend, Robert Christianson, testified that he had received a strange phone call from Sullivan a few days before Lita's murder, asking Christianson if he had seen any suspicious or unusual activity around Lita's house. This would tie in with Harwood's first visit to Lita's home. Despite his initial confession, Harwood changed his story a number of times. He testified that he first met James Sullivan in November 1986, when, as an employee of North American Van Lines, he transported Sullivan's baby grand piano from an address in Macon, Georgia, to the Palm Beach mansion. Sullivan confided in Harwood that he was having some problems with his wife and wanted someone to "take care" of the problem. Harwood agreed to help for the sum of $25,000, half of which was to be paid up front. Harwood said at the time that he doubted that Sullivan was serious, but within the next month he received two checks from him for the total sum of $12,500. Once Harwood realized that Sullivan was deadly serious, he became afraid that if he didn't follow through with his part of the bargain, the millionaire might have him killed too.

Harwood claimed that he contacted a dancer and a bartender he knew from a strip club and got them to join in with the scheme. On their first attempt to visit Lita, they failed to get her to come to the door.

Harwood said that he and the bartender returned three days later. He admitted to buying the roses but said that the bartender, known only as "John," took the flowers to the door and shot Lita while Harwood waited in the car. After the killing, they drove away and "John" threw the murder weapon out the window. At a rest stop a short distance away, Harwood made a phone call to Sullivan with a coded message to let him know that the job was done. Harwood said that he collected the rest of the money from Sullivan in a diner restroom in August. His former girlfriend, Belinda Trahan, testified that it was in February.

Ed Garland, Sullivan's defense lawyer, told *Dateline*'s Victoria Corderi that Harwood's testimony was so contradictory and self-destructive that the defense didn't even need to cross-examine him. The defense also cast doubt on Belinda Trahan's testimony by arguing that the lapses in her memory, such as the name and exact location of the diner, showed that the incident never took place and that she had merely concocted and rehearsed her story. Sullivan did not testify, but remained silent and emotionless throughout the proceedings.

The jury began deliberations on March 10, 2006. Within less than five hours, it had found Sullivan guilty of murder. He was sentenced to life in prison without parole.

According to Michele Dargan, writer for the *Palm Beach Daily News*, jurors did not give credence to the testimony from either Belinda Trahan or Anthony Harwood because of their inconsistencies. Instead, they reached their verdict based on the testimony of the phone records tracing collect calls from Harwood to Sullivan shortly before and after the murder.

JAMES SULLIVAN APPEALS

In September 2008, Sullivan's lawyer, Donald Samuel, appealed to the Georgia Supreme Court to grant Sullivan a new trial. The *Atlanta Journal and Constitution* reported that the basis of Sullivan's appeal was a challenge to the search warrant used to seize evidence from his Palm Beach mansion. Samuel claims that the warrant was defective due to omissions and undisclosed facts, including the fact that information pertinent to the warrant was obtained from an FBI informant who had been arrested on a number of occasions for fraud and forgery,

which the warrant did not disclose. According to Fulton prosecutor Anna Green Cross, the warrant was legitimate because all the information had been independently corroborated by investigators. Authorities used the warrant to obtain diaries containing detailed notes of Sullivan's schedules and meetings. Despite the appeal, the supreme court unanimously decided to uphold the conviction.

Tony Harwood's prison release is scheduled for 2017. To date, Lita McClinton's parents have not received any of the civil judgment, now worth $9 million, against Jim Sullivan.

HATE CRIME

LGBT Murders in Atlanta

Atlanta, like many metropolitan cities, has a significant lesbian, gay and transgendered community. According to a 2006 report by the *Seattle Times*, the city has the country's third highest percentage, with 12.8 percent of the city's total population recognizing themselves as lesbian, gay or bisexual. Despite the fact that Atlanta has numerous LGBT businesses, a thriving social scene and a generally inviting and accepting atmosphere for people of varied sexual orientation, there have been a number of violent hate crimes committed against members of the LGBT community over the past fifteen years, many of which have never been solved.

The FBI's definition of a hate crime is "a criminal offense committed against a person, property or society which is motivated, in whole or in part, by the offender's bias against a race, religion, disability, sexual orientation, or ethnicity/national origin." In 1990, President George H.W. Bush signed in the Hate Crimes Statistic Act, which requires the attorney general to collect and publish data on crimes committed because of bias against the victim's sexual orientation, religion, race, disability or ethnicity. Though the act originally only required the data to be published for five years, it was extended indefinitely in 1994. More than a decade later, many experts agree that the system is hampered by errors, misinformation and incorrect data. The project is further disabled by the fact that reporting under the act is voluntary and more than one third of police jurisdictions have chosen not to

participate in submitting data. What this means is that a vast number of hate crimes do not show up in the national statistics.

Though some states are attempting to address the problem of gender-biased hate crimes, some still treat the issue as insignificant. Georgia is one of only six remaining states in the country that has no state-based criminal hate crime legislation of any kind (the other five are Arkansas, Hawaii, South Carolina, Indiana and Wyoming). There is still hope that Georgia may be moving closer to putting this legislation in place. On May 1, 2009, the Local Law Enforcement Hate Crimes Prevention Act was passed in the House of Representatives and now moves to the Senate. President Obama is urging the passing of this bill to enhance civil rights.

The National Coalition of Anti-Violence Programs (NCAVP) addresses and seeks to remedy the problem of violence committed against the lesbian, gay, bisexual and transgender communities. NCAVP has been collecting its own data on anti-LGBT violence, and in 2008 it received reports of 2,424 incidents, which showed a 26 percent increase over a two-year period. Known anti-LGBT murders rose 28 percent from 2007 to 2008, which put them at the highest level since 1999. The same reports also reveal an increase of weapons used in this type of hate crime and an increase in reports from victims between fifteen and eighteen years old. These statistics are limited by the number of states which NCAVP members were reporting from and only include Texas, Colorado, California, Kansas, Illinois, Minnesota, Michigan, Ohio, New York, Wisconsin and Pennsylvania.

THE BOMBING OF THE OTHERSIDE LOUNGE

The Otherside Lounge was a gay nightclub located on Piedmont Road in Atlanta. Owned by long-term life partners Beverly McMahon and Dana Ford, the club had been open for seven years and was popular among Atlanta's LGBT community; it had a predominantly lesbian clientele.

On Friday, February 21, 1997, about 150 people were hanging out at the Otherside. At 9:58 p.m., a bomb exploded from a stone ledge overlooking the back patio. Because it was cold outside, the patio was empty, but the force of the blast flung nails into the building, injuring

five patrons. Police later found a second bomb hidden in some bushes in a parking lot next to the club; this was detonated by a remote-control robot.

Memrie Wells-Cresswell was in the club that night, celebrating her friend's birthday, when the bomb exploded. Memrie told CNN that when she noticed her arm was bleeding profusely, she initially thought that she had been shot. Fortunately, there were a couple of medical technicians drinking at the bar, and they helped to stem the bleeding until the paramedics arrived. Memrie sustained the worst injury of the hurt patrons from a four-inch nail that pierced her arm, severing her brachial artery. But the injury and subsequent surgery were not the only pain that Memrie suffered from the explosion. At the time of the bombing, the twenty-eight-year-old had only confided to a few of her closest friends that she was a lesbian. That was soon to change when Atlanta mayor Bill Campbell released a statement to the media about the bombing that named Memrie Wells-Cresswell as a victim. Several months later, she was let go from her job as a real estate agent because of her sexuality. She also told CNN that her former company offered her money not to file a lawsuit.

THE INVESTIGATION

The incident was the fourth bombing attack to occur in Atlanta within a period of seven months. Investigators found similarities between the Otherside Lounge bombing and the bombings at the Centennial Olympic Park on July 27, 1996, and the bombing of a Northside Family Planning Services Clinic in Sandy Springs on January 16, 1997. Among the similarities were the facts that in each case the bomb was left in a knapsack, nails had been used in all the bombs and in the Sandy Springs and Otherside Lounge incidents a second bomb had been planted. Police officers believed that the secondary bombs were intended to harm police and medical personnel responding to the initial explosions.

Within a few days of the Otherside bombing, authorities received notification from two organizations, each claiming responsibility. The first was in the form of four letters sent to several news agencies and came from an organization known as the Army of God, an extremist antiabortion organization. The group claimed responsibility for all

three bombings, and the letters also threatened more attacks on gays and lesbians as well as abortion clinics. The second claim came from an organization called Sons of the Confederate Klan, a neo-Nazi group based in Los Angeles. A female member of the group made a telephone call to the Atlanta gay community Yellow Pages claiming that the group was responsible for the Otherside Lounge bomb. The FBI had meanwhile kept a number of details about the bombings from the media, but in March 1997 they disclosed that they were investigating whether the incidents were the work of a single bomber.

SOLIDARITY WITHIN THE COMMUNITY

The Atlanta LGBT community pulled together and organized meetings and events and also helped increase the security at local bars. Mayor Bill Campbell donated $2,000 of his campaign money to a fund that steadily grew to a $10,000 reward for anyone who could give information about the bombing that would lead to an arrest. Elizabeth Birch—executive director of the Human Rights Campaign, a national gay political advocacy organization—liaised with a number of organizations that had spoken out in condemnation of the Sandy Springs Family Planning Clinic bombing. The Family Research Council and the Christian Coalition were two of the organizations that agreed to also denounce the Otherside bombing. Not long after the bombing, the LGBT community held a rally for Nonviolent Social Change at the Martin Luther King Jr. Center. Over one thousand gay and straight people attended to show support for the victims, including the husband of one of the victims killed by the Olympic Park bomb. The Otherside reopened its doors, determined to continue to welcome clients, old and new.

CAPTURING THE FUGITIVE

Eric Rudolph, a white male, was born on September 19, 1966, in Merritt Island, Florida. After his father's death in 1981, he moved with his mother and siblings to the rural area of Nantahala, North Carolina. After dropping out of high school following ninth grade,

Rudolph spent a year as an apprentice carpenter. In 1987, he enlisted in the U.S Army and underwent basic training at Georgia's Fort Benning. He was discharged in 1989 during service at Fort Campbell in Kentucky. He was known to be a survivalist, and was very familiar with the Nantahala region from hiking and camping there throughout his youth.

In February 1998, the U.S. Department of Justice charged Rudolph with the bombing of the New All Women Health Care Clinic in Birmingham, Alabama. Eight months later, Rudolph was charged with the bombings at Centennial Olympic Park, Atlanta Northside Family Planning Service clinic and the Otherside Lounge.

Rudolph had been a fugitive since the Birmingham clinic bombing, and authorities believed that he was hiding out in the mountains of the Nantahala National Forest, possibly close to the town of Murphy, where he was raised. He had last been seen in July 1998, when he bought supplies from a health food store owned by an old friend in Murphy.

The FBI sent hundreds of agents to scour the area. Despite the help of local hunters and residents and a $24 million budget, Rudolph managed to avoid capture for five years. When he was finally captured, it was quite by chance.

At 4:00 a.m. on Saturday, May 31, 2003, twenty-one-year-old Officer Jeffrey Scott Postell was making a routine patrol behind a Save-a-Lot grocery store in Murphy. The officer spotted Rudolph crouching behind some milk crates and arrested him under the assumption that he had caught him in the act of a robbery. When Rudolph was unable to produce any identification, Postell assumed that he was a homeless person searching for food. At the police headquarters, however, Rudolph was not so lucky, and the sheriff's deputy immediately recognized him from the FBI's most wanted list.

Though authorities investigated whether any local residents had been helping Rudolph avoid capture, they could not find any evidence, although when captured the fugitive was well kempt and had recently had a haircut.

On August 13, 2005, Rudolph pleaded guilty to all four bombings in order to avoid the death penalty. As part of his plea bargain, he told police the whereabouts of three locations where he had stashed explosives, one of which also contained a fully assembled bomb to which the detonator was not yet attached. Rudolph was sentenced to life in

prison without parole. In the eleven-page confession that he submitted to prosecutors, Rudolph detailed his views on homosexuality:

> *Homosexuality is an aberrant sexual behavior, and as such I have complete sympathy and understanding for those who are suffering from this condition. Practiced by consenting adults within the confines of their own private lives, homosexuality is not a threat to society. Those consenting adults practicing this behavior in privacy should not be hassled by a society which respects the sanctity of private sexual life. But when the attempt is made to drag this practice out of the closet and into the public square in an "in your face" attempt to force society to accept and recognize this behavior as being just as legitimate and normal as the natural man/woman relationship, every effort should be made, including force if necessary, to halt this effort.*
>
> *This effort is commonly known as the homosexual agenda. Whether it is gay marriage, homosexual adoption, hate crimes laws including gays, or the attempt to introduce a homosexual normalizing curriculum into our schools, all of these efforts should be ruthlessly opposed. The existence of our culture depends upon it. It is the duty of the state to promote the public welfare and this includes holding up values and model behaviors which tend to create a healthy society capable of reproducing itself by the natural means of the family unit. This model behavior which lies at the heart of a healthy society is the marriage between a man and a woman. To place the homosexual relationship along side of the model and pronounce it to be just as legitimate a lifestyle choice is a direct assault upon the long-term health and integrity of civilization and a vital threat to the very foundation of society—and this foundation is a family hearth.*
>
> *Any conscientious individual afflicted with homosexuality should acknowledge that a healthy society requires a model of sexual behavior to be held up and maintained without assault. Like other humans suffering from various disabilities homosexuals should not attempt to infect the rest of society with their particular illness.*

Rudolph has never spoken to the media, but several of his letters and essays written during his time in jail have been posted on the extremist antiabortion website ArmyofGod.com since his guilty plea. The content of the documents illustrate Rudolph's belief in the moral justification of his actions as well as his complete lack of remorse.

ATLANTA'S HATE CRIME WAVE

Between December 1990 and November 1995, there were a number of violent transgender murders in Atlanta. All the victims were male to female transgendered persons, all the identified victims were dressed as women, all were African American and all were shot or beaten to death. Not a single case has been solved. Though many activists and members of Atlanta's LGBT community believe that the murders are the work of the same killer—particularly four attacks in 1991 that happened within two months of one another—authorities insist that the cases are not connected.

ATLANTA'S TRANSGENDER MURDER VICTIMS

Edna Brown, a receptionist and stage performer also known as "Madame," was shot to death in her Atlanta home on December 24, 1990. The police arrested Edna's boyfriend, Sanders L. Taylor, for the crime. In court, Taylor reportedly received a plea bargain. The judge accepted a guilty plea to a charge of theft by receiving and the murder charge was not further addressed.

An unidentified person. The body of a transgendered person was found murdered in Atlanta on October 29, 1991. Death was caused by violent blows to the head.

Hurielle "Gypsy" Lockett, aka David King, age twenty-eight, was found near a dumpster in southeast Atlanta on October 14, 1991. She had been killed by a gunshot to the head.

Rhonda Star aka Ronnie Dean Lyles was killed by a gunshot wound to the head on October 29, 1991. Her body was dumped alongside Interstate 85 close to the North Druid Hills area in DeKalb County.

Jean (Woodrow) Powell, age thirty-three, was killed by a single gunshot to the back on November 11, 1991. Jean was a friend of Edna Brown's. Her body was found outside an apartment building on Ashby Street.

An unidentified transgender person was found murdered in Atlanta on December 20, 1992. She had been shot to death.

Anthony Swain, **aka Diane**, age thirty-six, was found shot through the head on November 8, 1992. Her body was found on Field Road in northwest Atlanta.

Derry Glenn, aka Desiree Allen, was found shot to death in Atlanta on December 19, 1992.

Quincy Favors Taylor, a fifteen-year-old transgendered performer, was found killed by a single gunshot wound to the chest on October 11, 1995. The body was found behind the A&P grocery store on Marietta Boulevard.

Transgender murders continue to be underreported and under-investigated. Taneika Taylor, director of communications, and her team at GenderPAC are fighting to increase community awareness and highlight concerns about these cases.

> *Raising awareness really is the first step that we can take in terms of transforming the culture that has allowed these murders to happen in a way that they're under-solved* [and] *under-reported by most media outlets, outside the LGBT community…We hope that people will recognize the sorts of violence and aggression that American culture has become accepting of, in terms of enforcing masculinity or femininity.*

THE MURDER OF PRECIOUS ARMANI

Precious Armani was a preoperative male to female transsexual from Atlanta. She was shot to death in the head on February 29, 2004. Her body was found in a white Chevrolet that had been rented by her friend at an apartment complex located on the 2400 block of Peachtree Street. Precious had been living in the apartment building for several weeks with a long-term friend. Her body was found by residents.

Precious Armani.

During the investigation of the crime scene, Atlanta Police discovered DNA evidence in the car. For three years, the GBI had been examining the sample with no results until it had a breakthrough on August 15, 2006, when the DNA was matched to an Atlanta man. This made him the third man to be investigated by the Atlanta Police Department in this case, though the previous two were quickly eliminated. The suspect denied knowing Precious Armani, and the police were unable to pull any evidence to link him to her murder. In a statement to *Southern Voice Atlanta* in 2006, Detective David Quinn of the Atlanta homicide squad reported that Precious Armani may have been murdered as part of a robbery, as no money or purse was found at the scene. The murder remains unsolved.

POLICE LIAISON WITH THE LGBT COMMUNITY

Crimes motivated by bias, whether it is homophobia or racism, not only impact the victim's family but also the community as a whole. In an attempt to address this problem, Police Chief Richard Pennington created the gay liaison post shortly after taking over as the head of the Atlanta Police Department in 2002. A few months later, the Atlanta Police Department appointed its first LGBT liaison officer. The aim of the program was to ease the tension between Atlanta Police and members of the city's LGBT community. Connie Locke

was appointed in March 2002, and she worked hard to change some of the department's policies. One of the changes she implemented was that if a crime was thought to be a direct result of the victim's orientation, then the responding officer would immediately contact Locke and she would work alongside the officer to investigate the crime. One of the cases that Locke assisted with was the Precious Armani case. During the investigation, Locke canvassed Atlanta gay bars, including Metro, Model T's, Bulldogs, New Order and Backstreet, in search of clues in the murder.

Locke had already completed fifteen years of service when she took on the job as the liaison officer full time. As a lesbian herself, Locke said that she felt it helped her to build up trust and understanding within the LGBT community. She used the Washington, D.C.'s Gay and Lesbian Liaison Unit as a model for her work in Atlanta. She also worked with the Atlanta Police Academy, where she taught a class entitled "Cultural Diversity II: Understanding the Gay Community and Hate/Bias Crimes" to all recruits. She believed that the course went a long way toward raising awareness, as most recruits had very little or no contact with people in the LGBT community. Locke was also responsible for setting up a citizen task force in 2002. The task force—made up of seven demographic categories, including local businesspeople, youth and nonprofit organizations—was to hold monthly meetings with Locke to discuss issues concerning lesbians, gay men and transgendered people when dealing with law enforcement. Connie Locke retired in August 2005 and was replaced by Officer Darlene Harris. Harris, thirty-six, is a lesbian who lives with her life partner and two children in DeKalb County. She worked as a patrol officer in the Buckhead area for two years prior to taking the liaison post.

Hopefully, if police continue to liaise with the LGBT community, they can reduce the number of hate crimes in Atlanta and work together to bring resolution to the many unsolved cases.

Historical Markers

Mary Phagan's Grave
Old Marietta City Cemetery
395 Powder Springs Street
Marietta, GA 30060
Latitude: 33.9436879349
Longitude: -84.5473292378

Fort Peachtree Site
Marker is at the intersection of Ridgeview Road and Ridgeview Circle, on the right when traveling north on Ridgeview Road. This marker is located in the front yard of a home. Please be respectful of private property.
Latitude: 33.83135
Longitude: -84.44901

Battle of Peachtree Creek
Palisades Road near Peachtree Road, Atlanta.
Latitude: 33.804833
Longitude: -84.39333

Montgomery Family Cemetery
On the west side of Marietta Boulevard, a quarter mile south of Bolton Road, Atlanta.
Latitude: 33.81935
Longitude: -84.4517

Montgomery-DeFoor House Site
Located at the intersection of Moore's Mill Road and Bolton Road in Atlanta.
Latitude: 33.82075
Longitude: -84.45111

Montgomery/DeFoor's Ferry
At Fort Peach Tree, Atlanta Water Works, off Ridgewood Road.
Latitude: 33.828033
Longitude: -84.45401

Old Montgomery Ferry Road
Twenty-eight Street and Wycliff Road, Atlanta.
Latitude: 33.805483
Longitude: -84.39588

Appendix II

ORGANIZATIONS AND CONTACTS

HISTORICAL

Atlanta History Center
130 West Paces Ferry Road
Atlanta, GA 30305
Tel: 404-814-4000

Georgia Historical Society
260 Fourteenth Street NW, Suite A-148
Atlanta, GA 30318
Tel: 404-376-8161

Cobb Landmarks and Historical Society
145 Denmcad Street
Marietta, GA 30060
Tel: 770-426-4982

LGBT

Atlanta Gay and Lesbian Chamber of Commerce
2107 North Decatur Road, Suite 190
Decatur, GA 30033
Tel: 404-377-4258
E-mail: admin@atlantagaychamber.org

Emory LGBT Life
Dobbs University Center, Room 246E
605 Asbury Circle
Atlanta, GA 30322
Tel: 404-727-0272
E-mail: lgbt@emory.edu

Georgia Equality
1530 DeKalb Avenue NE, Suite A
Atlanta, GA 30307
Tel: 404-523-3070

National Gender Alliance
PO Box 2312
Chicago, IL 60690
Tel: 312-472-4518

National Gender Disphoria Organization and Support
PO Box 02732
Detroit, MI 48202
Tel: 313-842-5258

National Gay and Lesbian Task Force
1325 Massachusetts Avenue NW, Suite 600
Washington, D.C. 20005
Tel: 202-393-5177

National Coalition of Anti-Violence Programs
240 West Thirty-fifth Street, Suite 200
New York, NY 10001
Tel: 212-714-1184
E-mail: info@ncavp.org

INVESTIGATIVE

Atlanta Police Department

675 Ponce de Leon Avenue
Atlanta, GA 30308
Police Information: 404-546-2374
Drug Hotline: 404-853-3444
Public Affairs: 404-817-6873

Open Records Unit

Georgia Bureau of Investigation
3121 Panthersville Road
Decatur, Georgia 30034
Tel 404-270-8527

Atlanta Police LGBT Liaison

675 Ponce De Leon Avenue
Atlanta, GA 30308
Tel: 404-817-6710

Appendix III

FURTHER READING

GEORGIA HISTORY

Bartley, Numan V. *The Creation of Modern Georgia*. Athens: University of Georgia Press, 1990.

Byrnside, Ronald L. *Music in Eighteenth-Century Georgia*. Athens: University of Georgia Press, 1997.

Cobb, James Charles. *Georgia Odyssey*. Athens: University of Georgia Press, 1997.

Coleman, Kenneth. *The American Revolution in Georgia, 1763–1789*. Athens: University of Georgia Press, 1958.

———. *Georgia History in Outline*. Athens: University of Georgia Press, 1978.

———. *A History of Georgia*. Athens: University of Georgia Press, 1991.

Coulter, Ellis Merton. *Georgia: A Short History*. Athens: University of North Carolina Press, 1960.

Dittmer, John. *Black Georgia in the Progressive Era, 1900–1920*. Champaign: University of Illinois Press, 1980.

Drago, Edmund L. *Black Politicians and Reconstruction in Georgia: A Splendid Failure*. Athens: University of Georgia Press, 1992.

Fleischmann, Arnold, and Carol Pierannunzi. *Politics in Georgia*. Athens: University of Georgia Press, 1997.

Grimes, Millard B. *The Last Linotype: The Story of Georgia and Its Newspapers Since World War II*. Macon, GA: Mercer University Press, 1985.

Harris, Joel Chandler. *Georgia from the Invasion of De Soto to Recent Times*. New York: D. Appleton and Company, 1896.

Henderson, Harold P., and Gary L. Roberts, eds. *Georgia Governors in an Age of Change: From Ellis Arnall to George Busbee*. Athens: University of Georgia Press, 1988.

Jackson, Harvey H., and Phinizy Spalding, eds. *Forty Years of Diversity: Essays on Colonial Georgia*. Athens: University of Georgia Press, 1984.

King, Spencer B., Jr. *Georgia Voices: A Documentary History to 1872*. Athens: University of Georgia Press, 1966.

Kytle, Calvin, and James A. Mackay. *Who Runs Georgia?* Athens: University of Georgia Press, 1998.

Lamplugh, George R. *Politics on the Periphery: Factions and Parties in Georgia, 1783–1806*. Newark: University of Delaware Press, 1986.

Lane, Mills. *The People of Georgia: An Illustrated Social History*. Upperville, VA: Beehive Press, 1975.

McDonald, Laughlin. *A Voting Rights Odyssey: Black Enfranchisement in Georgia*. Cambridge: Cambridge University Press, 2003.

Moore, Andrew S. *The South's Tolerable Alien: Roman Catholics in Alabama and Georgia, 1945–1970*. Baton Rouge: Louisiana State University Press, 2007.

Nasmyth, Peter. *Georgia: In the Mountains of Poetry*. New York: Routledge, 2001. Revised edition.

Owen, Christopher H. *The Sacred Flame of Love: Methodism and Society in Nineteenth-Century Georgia*. Athens: University of Georgia Press, 1998.

Price, Michael E. *Stories with a Moral: Literature and Society in Nineteenth-Century Georgia*. Athens: University of Georgia Press, 2000.

Scales, John R. *Sherman Invades Georgia: Planning the North Georgia Campaign Using a Modern Perspective*. Annapolis, MD: Naval Institute Press, 2006.

Scott, Thomas Allan. *Cornerstones of Georgia History: Documents that Formed the State*. Athens: University of Georgia Press, 1995.

Shryock, Richard Harrison. *Georgia and the Union in 1850*. Durham, NC: Duke University Press, 1926.

Smith, George Gilman. *The History of Methodism in Georgia and Florida: From 1785 to 1865*. Macon, GA: J.W. Burke & Co., 1877.

Sullivan, Buddy. *Georgia: A State History*. Charleston, SC: Arcadia Publishing, 2003.

Thompson, Clara Mildred. *Reconstruction in Georgia: Economic, Social, Political, 1865–1872*. Manchester, NH: Ayer Publishing, 1971.

Tuck, Stephen G.N. *Beyond Atlanta: The Struggle for Racial Equality in Georgia, 1940–1980*. Athens: University of Georgia Press, 2001.

Wetherington, Mark V. *Plain Folk's Fight: The Civil War and Reconstruction in Piney Woods, Georgia*. Chapel Hill: University of North Carolina Press, 2005.

Wilson, David K. *The Southern Strategy: Britain's Conquest of South Carolina and Georgia, 1775–1780*. Columbia: University of South Carolina Press, 2005.

Wood, Betty. *Women's Work, Men's Work: The Informal Slave Economies of Lowcountry Georgia*. Athens: University of Georgia Press, 1995.

Wynne, Lewis Nicholas. *The Continuity of Cotton: Planter Politics in Georgia, 1865–1892*. Macon, GA: Mercer University Press, 1986.

CRIME/CRIMINOLOGY

Bonger, Willem. *An Introduction to Criminology*. London: Methuen & Co., Ltd., 1936.

Braithwaite, John. *Crime, Shame, and Reintegration*. Cambridge: Cambridge University Press, 1989.

Felson, R.B., and J.T. Tedeschi. "A Social Interactionist Approach to Violence: Cross-Cultural Applications." In *Interpersonal Violent Behaviors: Social and Cultural Aspects*, edited by R. Barry Ruback and Neil Alan Weiner. New York: Springer, n.d.

Ferrell, Jeff. *Crimes of Style: Urban Graffiti and the Politics of Criminality*. Boston: Northeastern University Press, 1996.

Keith, Michael. *Race, Riots, and Policing*. London: University College London Press, 1993.

Lock, Richard. *Violent Crime: Environment, Interaction, and Death*. Lexington, MA: Heath, Lexington Books, 1977.

Omi, Michael, and Howard Winant. *Racial Formation in the United States from the 1960s to the 1990s*. 2nd ed. New York: Routledge, 1994.

Platt, Anthony M. *The Child Savers: The Invention of Delinquency*. 1969. 2nd ed., Chicago: University of Chicago Press, 1977.

Quinney, Richard. *The Social Reality of Crime*. Boston: Little, Brown, 1970.

Reiman, Jeffrey H. *The Rich Get Richer and the Poor Get Prison: Ideology, Class, and Criminal Justice.* 1979. Boston: Allyn and Bacon, 1998.

Taylor, Ian, Paul Walton and Jock Young. *The New Criminology: For a Social Theory of Deviance.* New York: Harper and Row, 1973.

Thompson, E.P. *Whigs and Hunters: The Origins of the Black Act.* New York: Penguin Books, 1990.

LGBT

Adam, Barry. *The Rise of a Lesbian and Gay Movement.* 2nd ed. Boston: Twayne, 1995.

Aimone, Joseph O., Catherine A. MacGillivray and Thomas Calvin, eds. *Straight with a Twist: Queer Theory and the Subject of Heterosexuality.* Champaign: University of Illinois, n.d.

Bolin, Ann. *In Search of Eve: Transsexual Rites of Passage.* Santa Barbara, CA: Bergin and Garvey, 1988.

Boykin, Keith, and Ansa Boykin. *One More River to Cross: Black and Gay in America.* New York: Knopf Publishing Group, 1997.

Buxton, Amity Pierce. *The Other Side of the Closet: The Coming Out Crisis for Straight Spouses and Families.* New York: J. Wiley, 1994.

Cant, Bob, and Susan Hemmings, eds. *Radical Records: Thirty Years of Lesbian and Gay History, 1957–1987.* New York: Routledge, 1988.

Denny, Dallas. *Identity Management in Transsexualism.* King of Prussia, PA: Creative Design, 1994.

Green, Richard. *Sexual Science and the Law.* Cambridge, MA: Harvard University Press, 1992.

Herdt, Gilbert, ed. *Third Sex, Third Gender: Beyond Sexual Dimorphism in Culture and History.* New York: Zone, 1994.

Miller, Neil. *Out of the Past: Gay and Lesbian History from 1869 to the Present.* New York: Random House, 1995.

Pollock, Jill S. *Lesbian and Gay Families in America: Redefining Parenting in America.* New York: Franklin Watts, 1995.

Robson, Ruthann. *Lesbian (Out)Law: Survival Under the Rule of Law.* Ithaca, NY: Firebrand, 1992.

Zimmerman, Bonnie. *The Safe Sea of Women: Lesbian Fiction, 1969–1989.* Boston: Beacon, 1990.

Zimmerman, Bonnie, and Toni A.H. McNaron, eds. *The New Lesbian Studies: Into the Twenty-First Century.* New York: Feminist Press, 1996.

BIBLIOGRAPHY

INTRODUCTION

Federal Bureau of Investigation. *Uniform Crime Reports.* http://www.fbi.gov/ucr/ucr.htm.

Fox, J.A., and Zawitz, M.W. *Homicide Trends in the United States.* U.S. Department of Justice. http://www.ojp.usdoj.gov/bjs/homicide/homtrnd.htm.

ATLANTA'S FIRST HOMICIDES

Atlanta Constitution. "Lynch Law in Georgia." April 5, 1881.

Brundage, William Fitzhugh. *Lynching in the New South, Georgia and Virginia 1880–1930.* Champaign: University of Illinois Press, 1993.

Davis, Harold E. *Henry Grady's New South: Atlanta a Brave and Beautiful City.* Tuscaloosa: University of Alabama Press, 1990.

Harper's Weekly. "The Execution of Gordon, the Slave Trader." March 8, 1862.

Mancini, Mathew J. *One Dies Get Another: Convict Leasing in the American South, 1866–1929.* Columbia: University of South Carolina Press, 1996.

Martin, Thomas H. *Atlanta and Its Builders, a Comprehensive History of the Gate Builders.* N.p.: Century Memorial Publishing Company, 1902.

New York Times. "Lynch Law in the South." November 14, 1897.

———. "The Murder of Co. Alston." May 1, 1879.

———. "Speedy Justice to Murderers." July 1879.

Reed, Wallace Putnam. *History of Atlanta, Georgia.* N.p.: D. Mason & Co., 1889.

COPYCAT KILLER: THE ATLANTA RIPPER

Atlanta Constitution. "Negro 'Ripper' Is in the Toils, So Police Think." July 13, 1911.

———. "Negro Woman Slain by Jack the Ripper Found Early Sunday." July 27, 1914.

———. "Reign of Crime Grips Atlanta: Police Deified. Eighth Victim Taken by 'Jack the Ripper' Negro Held on Suspicion." July 12, 1911.

Fennessy, Steve. "Atlanta's Jack the Ripper." *Creative Loafing.* October 16, 2005.

New York Times. "Another Ripper Murder." May 1912.

———. "Eight Victims Now of Atlanta Ripper." July 1911.

A CASE OF DOUBT: THE MURDER OF MARY PHAGAN

Crime Library. "The Case of Leo Frank." http://www.trutv.com/library/crime/notorious_murders/not_guilty/frank/1.html.

Dinerstein, Leonard. *The Leo Frank Case.* Athens: University of Georgia Press, 2008.

Georgia's Virtual Vault. "Leo Frank Clemency Application and Other Documents and Letters." http://content.sos.state.ga.us.

Kansas City Star. "Has Georgia Condemned an Innocent Man to Die?" January 17, 1915.

New Georgia Encyclopedia. "Leo Frank Case." http://www.georgiaencyclopedia.org/nge/Article.jsp?id=h-906.

New York Times. "Acquits Burns Men in the Frank Case." February 1, 1915.

———. "Conley Notes Show Guilt, Says Burns." April 27, 1914.

———. "Sure Conley Slew Others." April 28, 1914.

Oney, Steve. *And the Dead Shall Rise.* New York: Random House, 2003.

Phagan, Mary. *The Murder of Little Mary Phagan.* Fair Hills, NJ: New Horizon Press, 1987.

Wytt, E. Thompson. *A Short Review of the Frank Case.* Atlanta, GA: 1914.

UNSOLVED: THE DeFOORS MURDERS

Atlanta Constitution. "The Danger of Tramps." July 30, 1879.

Garrett, Franklin. *Atlanta and Environs.* N.p.: Lewis Historical Publications, 1954.

Georgia News. "Man Confesses to the DeFoors Murder." N.d.

Kaufman, David R. *Peachtree Creek: A Natural and Unnatural History of Atlanta's Watershed.* Athens: University of Georgia Press, 2007.

New York Times. "An Aged Couple Murdered." July 27, 1879.

Rozema, Vicki. *Footsteps of the Cherokees: A Guide to the Homelands of the Eastern Cherokee Nation.* N.p.: John F. Blair, 2007.

THE DISAPPEARING BRIDE: MARY SHOTWELL LITTLE

Atlanta Journal and Constitution. "What Happened to Mary Shotwell Little? (Atlanta's 'Black Dahlia')." 2004.

Charley Project. "Mary Shotwell Little." http://www.charleyproject. org/cases/l/little_mary.html.

Great Bend Daily Tribune. "Girl Sent Five Roses; Found Dead in Her Car." 1967.

Nevada State Journal. "Girl's Body Found Stuffed in Car." 1967.

Ohio Times Recorder. "Body of 22-Year-Old Girl Found in Trunk of Her Car." 1967.

Sheboygan Press. "Hunt Stolen Car as Link to Slaying." 1967.

Serial Killing: The Atlanta Youth Murders

Adler, Jerry, and Vern E. Smith. "The Terror in Atlanta." *Newsweek.* March 2, 1981.

Associated Press. "DeKalb County Police Chief Resigns." May 4, 2006.

———. "Papers Sought in Ga. Child Killings." June 9, 2006.

———. "State Asks Judge to Turn Down Williams' Latest Conviction Challenge." June 22, 2006.

Atlanta Journal-Constitution. "Child Murders Given Ample Inquiry." June 22, 2006.

Bambara, Toni Cade. *These Bones Are Not My Child.* New York: Knopf Publishing Group, 2000.

Christian, Charles M., and Sari Bennett. *Black Saga.* New York: Basic Books, 1998.

CNN. "Atlanta Murder Case Re-opened." May 7, 2005.

Fisher, Joseph C. *A Killer Among Us: Pubic Reactions to Serial Murder.* Santa Barbara, CA: Praeger Publishers, 1997.

Headly, Bernard. *The Atlanta Youth Murders and the Politics of Race.* Edwardsville: Southern Illinois University Press, 1998.

Kadish, M.J., E.M. Davis and R.S. Kadish. "Fiber Evidence." *Trial Magazine.* August 1983.

Simpson, David. "DeKalb Drops 'Atlanta Child Murder' Investigation." *Atlanta Journal-Constitution.* June 20, 2006.

Webber, Harry R. "File in Ga. Child Murders Center of Fight." Associated Press. June 17, 2005.

———. "NA Gen US Atlanta Child Killings." *Associated Press.* August 6, 2005.

Murder for Hire:
The Killing of Lita McClinton Sullivan

Bell, Rachel. *Lita McClinton Sullivan Murder Case.* Crime Library on www.truTV.com.

Dargan, Michele. "Sullivan Gets Life without Parole." *Palm Beach Daily News.* March 15, 2006.

Jet. "White Millionaire, Suspected in Black Wife's 1987 Murder, Returned to US after Capture in Thailand." June 21, 2004.

Keller, Larry. "Star Witness Denies Shooting Ex-Palm Beacher Sullivan's Wife." *Palm Beach Post.* March 7, 2006.

MacQuarrie, Barrie. "A Rich Tale of Beauty, Death: Murder Fugitive Sought High Life." *Boston Globe.* May 10, 1998.

Niesse, Mark. "Husband Faces Trial in Socialite Slaying." Associated Press. June 7, 2004.

Rankin, Bill. "Sullivan Murder Verdict Stands." *Palm Beach Post.* September 22, 2008.

———. "Sullivan Seeks New Trial in Murder Conviction." *Atlanta Journal and Constitution.* September 9, 2008.

Schorn, Daniel. "Millionaire Manhunt." *CBS News.* July 21, 2007.

Spencer, Susan. "Long Search for Justice." *CBS News.* June 27, 2003.

Hate Crime: LGBT Murders in Atlanta

Ahmed, Saeed. "Vigil Honors Slaying Victim." *Atlanta Journal and Constitution.* March 2004.

Associated Press. "Rudolph Pleads Guilty to Series of Bombings." April 13, 2005.

Bagby, Dyanan. "Atlanta Police Match DNA to Suspect in Trans Slaying." *Southern Voice.* December 15, 2006.

CNN. Interview with Memrie Wells Creswell. Aired June 2, 2003.

———. "Rudolph Agrees to Plea Agreement." April 13, 2005.

CNN.com. "Bomb at Atlanta Nightclub Injures 5; 2nd Bomb Found Nearby." February 22, 1997.

———. "FBI: Atlanta Gay Bar Blast Raises Specter of 'Serial Bomber.'" February 22, 1997.

———. "Owner of Bombed Club Says Investigation 'Looking Good.'" February 25, 1997.

FBI. "Hate Crime Definition." http://www.fbi.gov.

Freeman, Scott. "A Hero in His Own Eyes: The Untold Story of Eric Robert Rudolph." *Creative Loafing.* July 26, 2006.

Gettlemen, J., and D.M. Halbfinger. "Suspect in '96 Olympic Bombing and 3 Other Attacks Is Caught." *New York Times.* June 1, 2003.

"Hate Violence against Lesbian, Gay, Bisexual, and Transgender People in the United States." NCAVP Report, 2008.

Intelligence Report. "Discounting Hate: Ten Years after Federal Officials Began Compiling National Hate Crime Statistics, the Numbers Don't Add Up." 2001.

Najafi, Yusef. "Transgender Tragedies: A New Analysis finds Washington, D.C. Topping the List in Transgender Murders." *Metro Weekly.* December 28, 2006.

NPR. "Full Text of Rudolph's Confession." April 14, 2005.

Remembering Our Dead. http://www.gender.org/remember/about/core.html.

Seattle Times. "Cities with Highest Percentages of Gays, Lesbians and Bisexuals." 2006.

About the Author

Corinna Underwood originates from England. She has been interested in all things mysterious and supernatural since she was a child. She has been freelance writing for more than ten years. For the past five years she has been a feature writer for *After Dark*, the monthly magazine owned by Art Bell, producer of radio show *Coast to Coast AM*. She also writes stories and novels for children. She now lives in Atlanta with her dog, Laszlo.